IMAGES
of America

WESTMINSTER

IMAGES
of America
WESTMINSTER

Westminster Historical Society

Donna DiRusso, Elizabeth Aveni, Elizabeth Bowen,
Elizabeth Hannula, and Elizabeth Smith

Donna M DiRusso

Betsy Hannula

Liddy Smith

Beth Bowen

ARCADIA

Betty Aveni

First printed in 2001.

Published by Arcadia Publishing,
an imprint of Tempus Publishing, Inc.
2A Cumberland Street
Charleston, SC 29401

Printed in Great Britain.

Library of Congress Catalog Card Number: 2001094287

For all general information contact Arcadia Publishing at:
Telephone 843-853-2070
Fax 843-853-0044
E-Mail sales@arcadiapublishing.com

For customer service and orders:
Toll-Free 1-888-313-2665

Visit us on the internet at http://www.arcadiapublishing.com

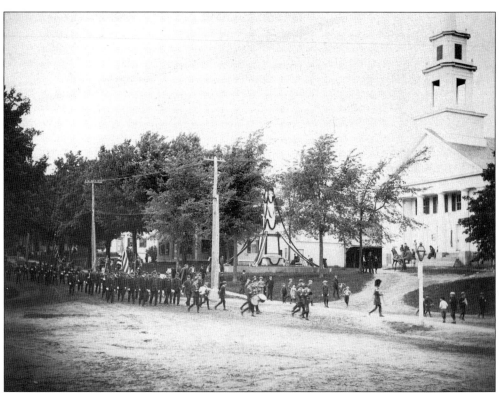

The Sons of the Civil War veterans parade past the Congregational church in 1909 to celebrate the 150th anniversary of the incorporation of the Town of Westminster.

CONTENTS

Acknowledgments 6

Introduction 7

1. Downtown 9

2. Around Town 23

3. Family, Friends, and Neighbors 39

4. Growing Up 55

5. Fruits of Our Labor 79

6. Serving Our Country 93

7. Remembering 111

ACKNOWLEDGMENTS

In October 2000, we gathered to begin the task of producing an *Images of America* book for Westminster. Telling Westminster's story in a vivid and exciting way was a daunting undertaking, and winnowing down the myriad of pictures from the extensive collection of the Westminster Historical Society (WHS) was a challenge. We made the decision to end this book with World War II and reviewed countless photographs to find the best in our collection. We hope, and believe, that we have captured the essence and the spirit of the people in Westminster.

As a committee, we want to give special thanks to those whose efforts were critical in making this book a reality: attorney John Bowen, whose wise counsel made us feel confident of the business side of our endeavor; Elaine Lawrence, for her contribution to the research; and especially Mark Landry, without whom the chapter titled "Serving Our Country" could not have been completed. His diligent research and thoughtful insight into that aspect of life in Westminster has been invaluable.

We thank the Board of Directors of the Westminster Historical Society for their encouragement and support and the many thoughtful people who shared their photographs with us. We also thank the Forbush Memorial Library trustees, who hold the stewardship of the paintings, for allowing us to use their images in this book. To our families and loved ones we can only say thank you for your support during our many months of work.

INTRODUCTION

No one knows what it was like that day in 1737 when Fairbanks Moor started out for the wilderness of central Massachusetts. Was it daylight or darkness, raining or sunny? Was he filled with excitement or nervously counting his footsteps as he set out to claim his territory in what a later compatriot could only call a "howling wilderness."

We do not know if he was able to see through the dense forests, was awed by the rising peak of Wachusett Mountain, or was captivated by the rolling hills of the countryside and the crystal-clear lakes of the region.

Perhaps he could have imagined the rude beginnings of a town that, 250 years later, would have a history of honing farmsteads out of the rugged New England hills, capturing the dynamic waterpower of its streams and nurturing bustling entrepreneurs, with box factories and paper mills dotting the countryside as the 19th century unfolded.

No doubt, Westminster's men marching off to fight at Gettysburg, sloshing through mud in Flanders, or winging their way across the darkened European skies of World War II Europe would have been inconceivable to Westminster's erstwhile first settler.

Almost certainly, no such thoughts were in the mind of Moor as he traveled west from Lancaster. A veteran of his own war, King Philip's tragic and destructive conflict, he had been rewarded with a grant of land in what was then known as Narragansett. He built the first house in what became Westminster, and others followed. Their hardy determination, their enterprising spirit, and their sense of community throughout Westminster's past are the threads that weave the history of the town together.

The images in this book feature church steeples rising against the sky and stone walls lining winding roads. Community spirit is evident as we see the Reed House being rolled down Main Street to make way for a new library, with the house's inhabitants never, for a moment, abandoning their daily pursuits. In these pages, the family at the old Judson Foster place gathers for a family photograph, the Wyman Mill turns out reams of paper, and young scholars tackle the day's lessons in one-room schools. These and numerous other images in *Westminster* aim to present the history of the town from the earliest times to the aftermath of World War II.

One
DOWNTOWN

Downtown has not always been where it is today in Westminster. The original settlement of houses and a meetinghouse, begun in 1737, was gathered around the common on Meetinghouse Hill. The main thoroughfare from Boston to Greenfield and Albany, built in 1800, followed a route over the hill, which became a lively and active place. Later, with the removal of the meetinghouse and the building of Westminster Academy, the area became the common on Academy Hill.

Times changed, however, when the route of the Fifth Turnpike, as it was known, was relocated around Academy Hill along what is now Leominster Street. Main Street then became the center of bustling activity, and the settlement grew to feature fine Greek Revival houses, beautiful white churches, thriving businesses, and popular hotels. The Westminster Cracker Factory, long a famous landmark in town, still occupies a central location in downtown Westminster. Later, other local gathering places, such as Ballou's Barbershop and Mansur's Dairy Bar, played important roles in the life of the town. Townspeople are proud that their center is listed on the National Register of Historic Places.

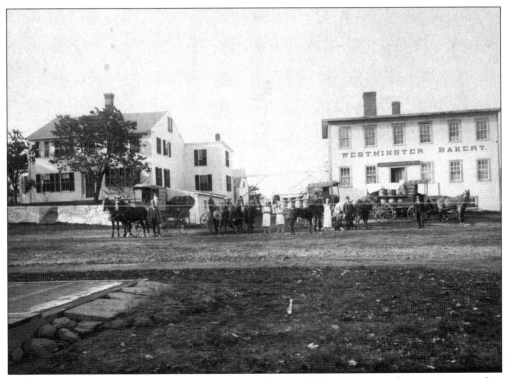

The Westminster Cracker Factory has been a focal point of the town since the company was first formed in 1828. Earlier names painted on the front of the red clapboard building have been Westminster Bakery and Westminster Crackers. The Dawley family has owned the bakery and the home next door for several decades. (WHS Collection; donated by heirs of Mary Barnes Wyman.)

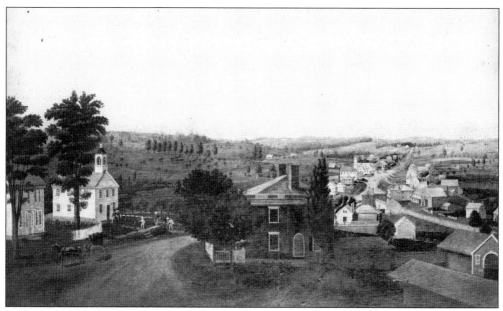

Widely known as a portrait painter, Dea. Robert Peckham painted only one landscape in his long career, that of his hometown, Westminster. Peckham climbed to the top of the belfry of the meetinghouse on top of Academy Hill in order to paint this scene of the road leading from the town common to the center of town in 1833. The Sargent home and Westminster Academy are on the left. The Squire Dustin home is on the right. (WHS Collection; donated by George Wood.)

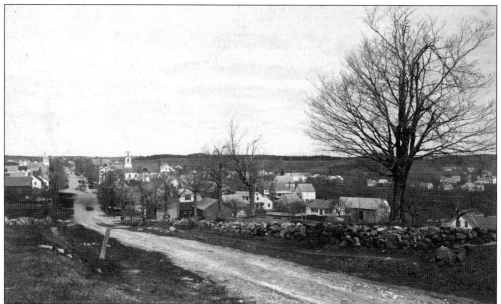

This view of the center of Westminster looks down Academy Hill and Main Street. The stone steps pictured in the front far left are what is left of the entrance to Westminster Academy. The absence of streetlights, telephone poles, and trolley tracks and the new location of the Congregational church date this picture to the mid-1800s. (WHS Collection; donated by the estate of George Brooks Swasey, M.D., by Artley Parsons.)

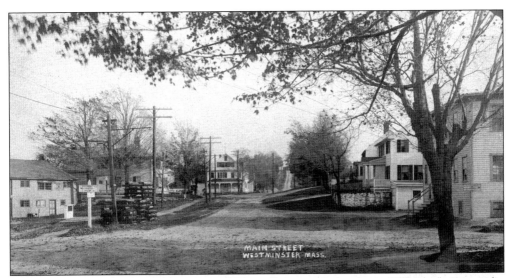

In the foreground is the intersection of Main Street and Academy Hill Road. Later, the turnpike was rerouted to go around to the left of Academy Hill instead of over it (today's Leominster Street). William Bradbury built the house in the center of the photograph, and it housed a store from 1829 to 1884. In the early 1900s, it was the home of the Arcangeli family, who came here from Italy. The house was taken down in 1918. (WHS Collection.)

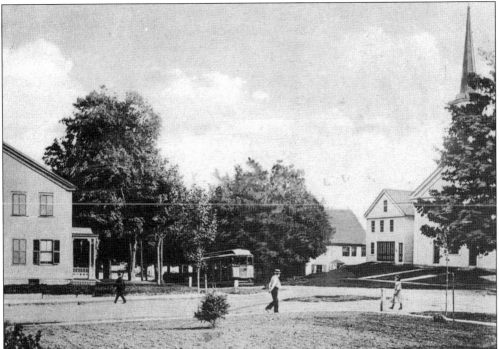

A trolley comes up Main Street in front of the Universalist church, which is now the American Legion Hall. The house on the left was built by Jonas Cutting in 1825. Edward Lynde, a butcher, had a lucrative meat market on the Bacon Street side for many years. John and Caroline Savage purchased the house and opened the first pharmacy. The old house is still clearly visible above the roofline of the present Westminster Pharmacy. (WHS Collection.)

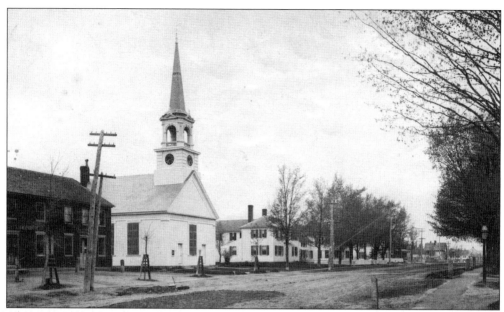

The newly planted trees were most likely elm trees, which lined Main Street from the late 1800s to the mid-1900s. In the middle is the First Baptist Church, next to the Brick Store. (WHS Collection; donated by the Bullard family.)

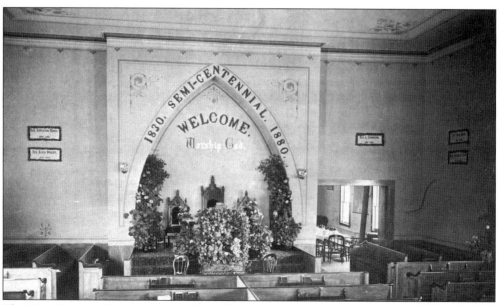

The First Baptist Church celebrated its 50th anniversary in 1880. The first building for the Baptist Society was on the shore of Meetinghouse Pond. This new church building was erected in 1863. The chapel was added in 1870 and the spire with bell and clock in 1872. (WHS Collection; donated by Mary Abar.)

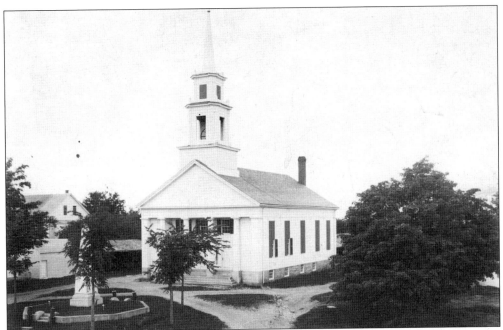

This Congregational church was built in 1837. Until then, the Congregationalists had worshipped in the meetinghouse, located on top of Meetinghouse Hill. In the 1820s, the Congregationalists built a new church in the village, which was growing with businesses and residences. (WHS Collection.)

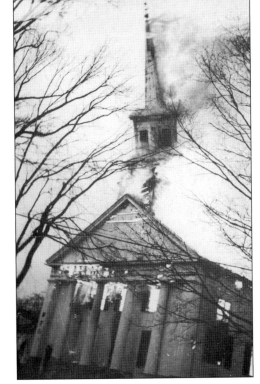

The Congregational church was destroyed by fire on the afternoon of November 10, 1940, after church services. The cause of the fire was never determined. The congregation immediately began to plan for the erection of another church building. The Yankee Street Fair was begun in the summer of 1941 to raise funds for the construction and has continued as a tradition ever since. (WHS Collection.)

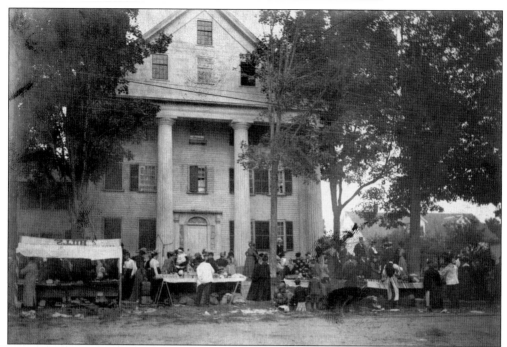

The Phineas Reed family owned this enormous four-story house at the corner of Main and Bacon Streets, where the library stands today. When it was decided that the town would build a library on that site *c.* 1900, the Reed House was moved. In this photograph, the family is having a yard sale before the big move. (WHS Collection; donated by Fraser Noble.)

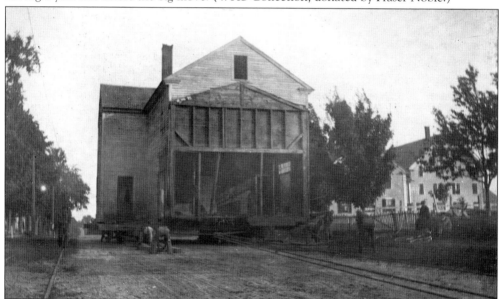

Moving the Reed House from its spot where the library now stands to its new location at the corner of Main and Eaton Streets took three weeks. Abbie Bell was a tenant in the Reed House. During the move, she rocked in her rocking chair, comforting her baby, and claimed her clock never stopped ticking. Moving houses was not uncommon and was skillfully accomplished with large rollers. (WHS Collection.)

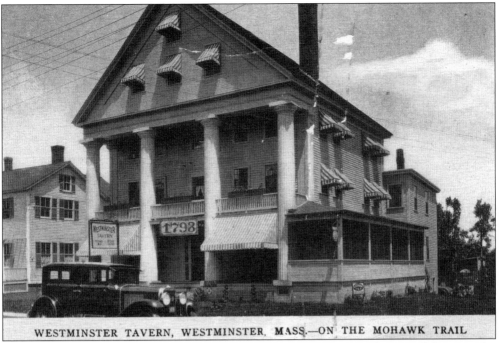

WESTMINSTER TAVERN, WESTMINSTER, MASS.—ON THE MOHAWK TRAIL

The former Phineas Reed house was purchased by Clinton Houghton and became the Westminster Tavern in 1906. It was located on the corner of Main and Eaton Streets. The tavern was a very popular restaurant during the early 1900s, especially for people who traveled through town on Route 2 on the popular Mohawk Trail. (WHS Collection.)

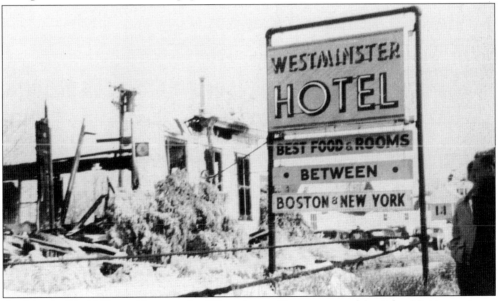

On March 13, 1948, at 11 p.m., the Westminster Tavern, owned by John Harrington, was destroyed by a fire that started in a gas refrigerator in the house next door. Because the house was at one time a part of the hotel, only six feet separated the two buildings, and the fire spread easily to the hotel. Two small children, Linda and Jennifer Smith, lost their lives in the fire. (WHS Collection; donated by John Fleck.)

During the early days of Westminster, when every family kept horses, cows, sheep, and goats, the town pound was used to gather animals that had strayed from their homes. It was originally on the north side of the common and was later moved to the south side next to the old Foster home. Pictured at the entrance is a little girl whose long white dress dates the photograph at 1900. (WHS Collection; donated by Stillman Whitney.)

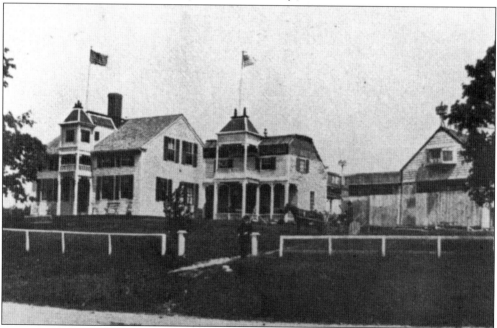

In 1836, the First Baptist Church parsonage was built by several of the brethren. It was located on Marshall Hill Road next to Meetinghouse Pond close by the church. It was sold in 1858 and was later owned by J. Sawin. (WHS Collection.)

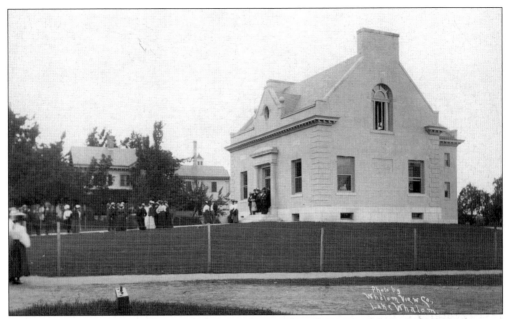

The Forbush Memorial Library was dedicated to its benefactors in 1902. A $10,000 bequest from Charles Forbush and contributions from the residents provided the funding to build this beautiful brick structure. Forbush had donated the funds in memory of his cousin Joseph Forbush in 1899. (WHS Collection.)

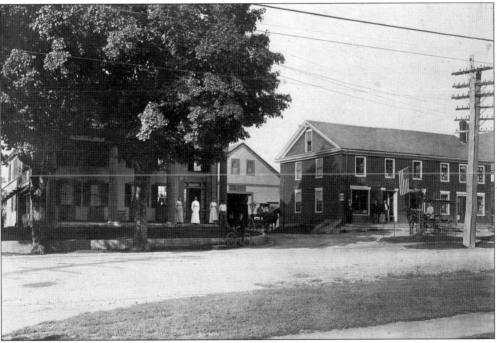

The old Brick Store, on Main Street, replaced a wooden structure and was home to many different businesses. The first store located here sold items such as handmade straw that was used to make bonnets. For years it housed the post office, the library, a cobbler shop, a barbershop, grocery stores, and a five-and-dime store. The Westminster Bank was established here in 1875.

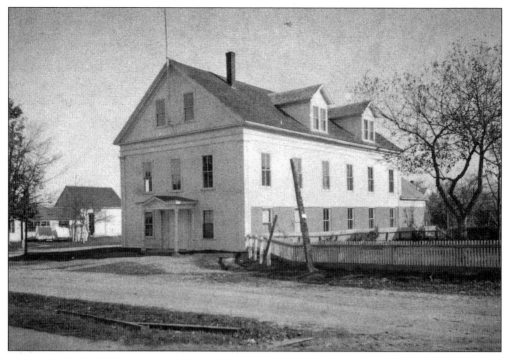

The Westminster Town Hall was built in 1839 and remodeled in 1855. From the single utility pole located to the right of the building, one can estimate the date of the photograph to be *c.* 1900. (WHS Collection.)

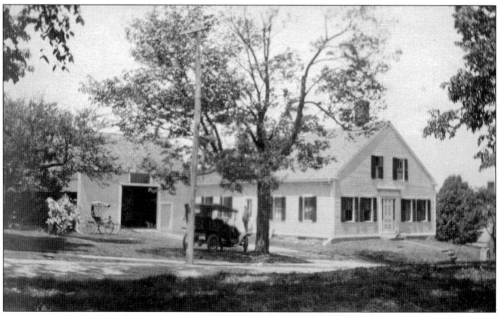

This house, located on Bacon Street, was built by Artemas Merriam in 1830 and passed to the Battles family. Later, Robert and Alberta Denton, longtime members of the historical society, inherited the house. (WHS Collection.)

This shop was located on Main Street where banks and shops are now located. It later became McMaster's Red and White Store, and then the Pantry Shelf. (WHS Collection; donated by Betty Aveni.)

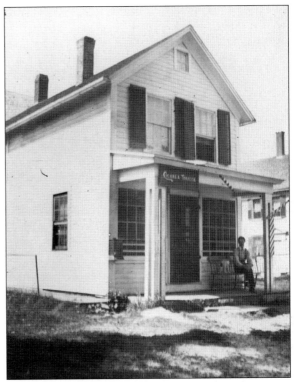

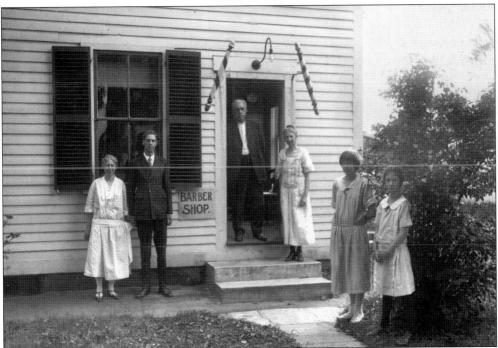

Ballou's Barbershop was on Main Street where Vincent's Country Store is today. This photograph shows John Francis Ballou, his wife, and his family c. 1925. (WHS Collection; donated by Evelyn Hachey.)

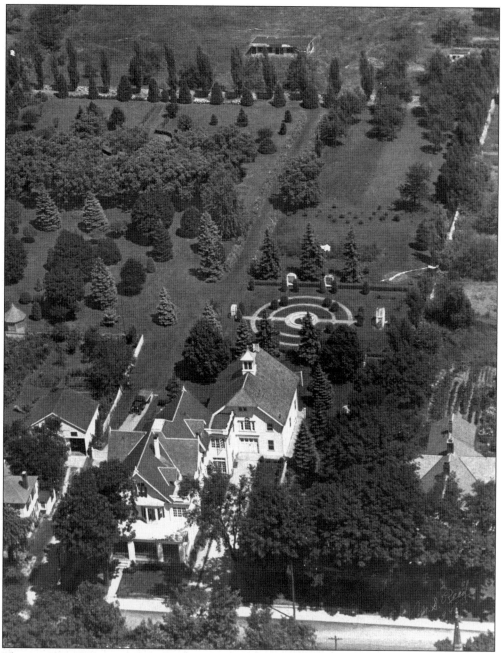

This is an aerial photograph, taken by M.S. Reed, of the north side of Main Street. It shows the extensive W.E. Putney estate, with its circular garden in the back. The gardens were the site of many charming lawn parties. Today, several families have apartments in the house. To the left is the present Westminster Historical Society house, at 110 Main Street. (WHS Collection.)

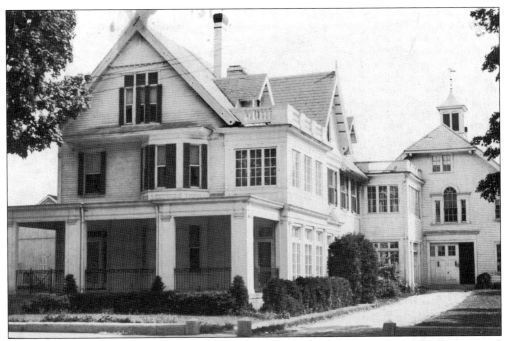

This house was designed by Mr. Thayer of Boston and was described as "a highly picturesque, late-Victorian Gothic/early Queen Anne house." The ornamental home was built by Dean Hill, a successful businessman, for his fourth wife. (WHS Collection.)

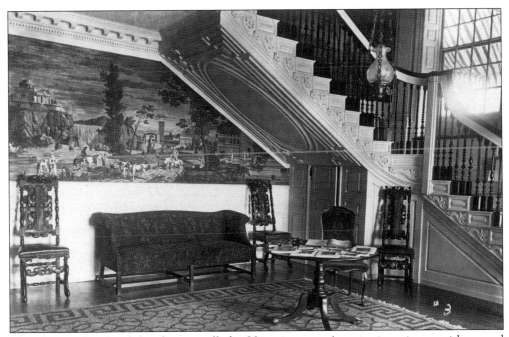

The elegant details of this foyer recall the Victorian era. A majestic staircase with carved wooden details greeted many guests as the Hill family entertained the town's many businessmen. (WHS Collection.)

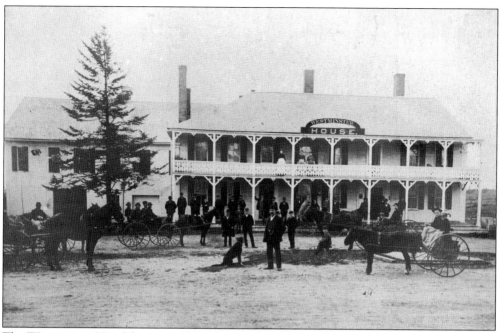

The Westminster Hotel first opened in 1799 on the south side of Main Street. It was destroyed by fire in 1903. In the summer, its pleasant, airy rooms attracted many visitors; in the winter, its sleigh rides, oyster suppers, and Westminster crackers were the highlights of the social scene. (WHS Collection.)

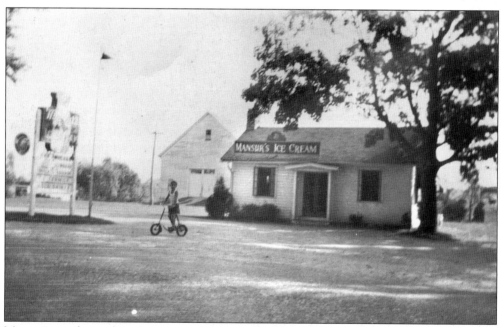

Mansur's was located in the center of town in the late 1920s, where the Westminster Hotel once stood. Later, the Chester Baker family purchased it, and Baker's Dairy Bar became a favorite gathering place. At the end of the century, the building was expanded to include a full-service restaurant, which was named the Little Town Hall. (Courtesy of Millie Lindreth.)

Two
AROUND TOWN

Travel around town could be a walk up Wachusett Mountain, a trolley ride from the Narrows to the Westminster Hotel, a wagon or bus ride to visit friends, or a Sunday drive by car or bicycle on the myriad lanes around town. The mode of transportation was often determined by the century in which one lived, although in Westminster, horses and carriages can still be spotted on the roads today. The images of families and homes in this chapter are reminders of a simpler time and the unique pleasures of living in a small town.

Westminster is one of the largest towns in the Commonwealth of Massachusetts, with 37.34 square miles of total area. Over five percent of the area is made up of lakes, ponds, and streams. Westminster was originally the six-square-mile Narragansett Township No. 2, granted to veterans (and their heirs) of King Philip's War in 1728. The first home was built in Westminster in 1737. After the town was incorporated in 1759, it grew steadily. Although it is now primarily residential, Westminster has been both a manufacturing and farming community. People often meander through town just for the pleasure of seeing this beautiful New England village.

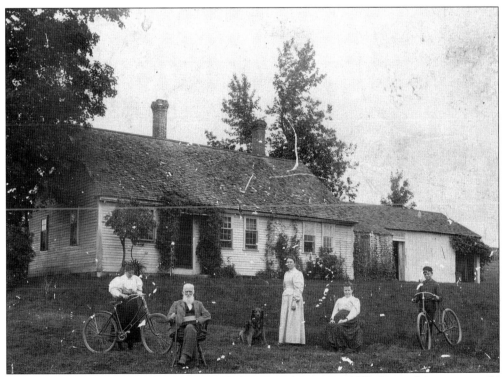

The Laws family built this large Cape-style home with a view of Wachusett Mountain at 54 Dean Hill Road in 1797. They occupied it for many generations, farming their 235 acres. Anna Laws, granddaughter of the original owners, remembers the swimming hole, the brook teeming with fish, and cousins visiting. (WHS Collection; donated by Betty Longley.)

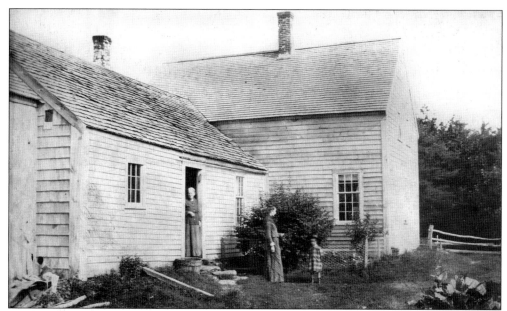

This small farmhouse at 82 Minott Road was built by Jonathan Sawin, a local carpenter, and sold to Asa Dike in 1870. Sally Sawin Dike is standing in the doorway; her daughter Mary Dike Wheeler and Mary's son are in the yard. Asa's grandfather was a colonel in the Revolutionary War. (WHS Collection; donated by Robert Mason.)

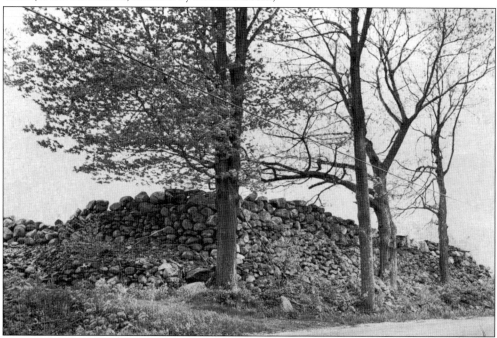

More than 100 years ago, Edmund Proctor built this fieldstone wall on his property at 89 North Common Road in order to hide from his neighbor, Farwell Morse, who lived across the street. Proctor insisted on doing his farm work on Sundays, and Morse was opposed to anyone working that day. The wall is imposing—about 11 feet high at the corner—and runs about 15 feet in front of the property and about 60 feet between the fields. (WHS Collection.)

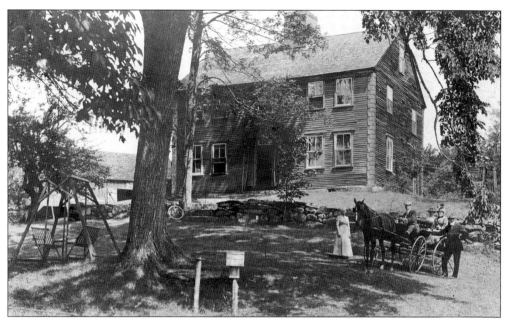

The Smith Tavern, at 31 Pierce Road (originally old Ashburnham Road), was the place to rest for travelers on the North Turnpike between Lunenburg and Winchendon in 1791. At one time, there was an underground passage to the house across the street to assist runaway slaves. The house has spectacular scenes painted on some walls by the well-known painter Rufus Porter. The Engman family restored this home. (WHS Collection.)

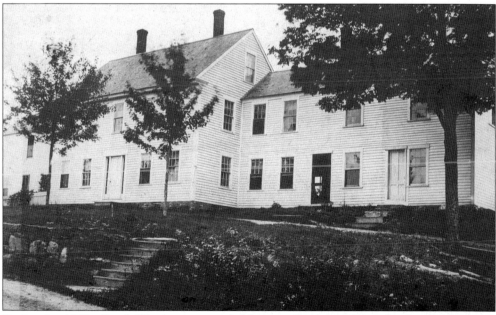

During the 1800s, South Westminster needed housing for the workers of its bustling factories and their families. Traveling along Spruce Road today, it is hard to imagine the many people, factories, and multifamily dwellings like the one in this picture. Harold Allen Towle, a local police officer prior to 1950, was born in this house in 1894. (WHS Collection; donated by H. Chester Towle.)

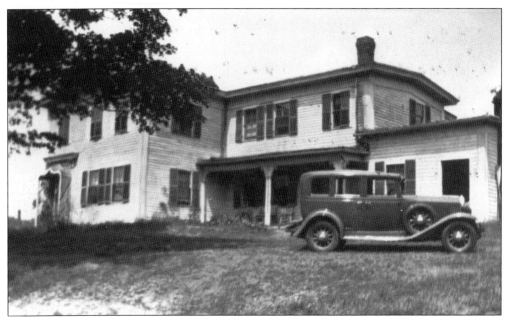

This building, at 110 Narrows Road, is the site of the original gristmill in Westminster. The grinding stone is still in the fieldstone cellar of the ell. Nathaniel Wood purchased this property in 1810; he built his home on part of the mill foundation and attached it to the ell. (Courtesy of the Bowen family.)

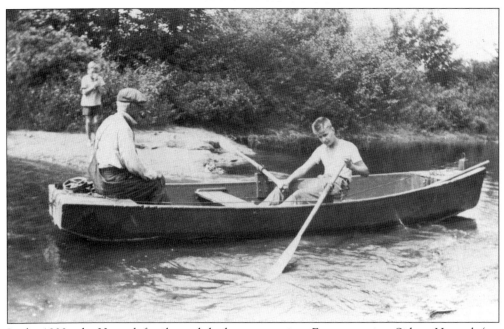

In the 1930s, the Harrock family used the house as an inn. Every morning, Sidney Harrock (on left in boat) would catch fish across the street in Wyman's Pond to feed his guests. This picture was taken around that time. Sidney served as the postmaster in Westminster for many years. (Courtesy of the Bowen family.)

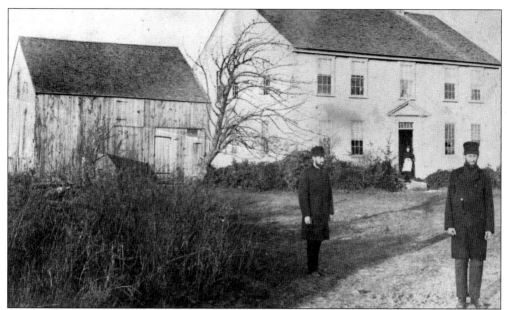

This old Colonial at 99 Overlook Road was built in 1789 by Benjamin Flint. The house can be identified by its two tall, white chimneys and small pane windows. Although there are no records indicating that this house was a tavern, the stagecoach route traveled in front of the house and there is a very large room on the second floor that appears to be a ballroom, both of which offer clues of its past. The road led to Aeolian Farm, owned by Elfrieda Eckels, who ran a horse farm on this property for many years. (WHS Collection.)

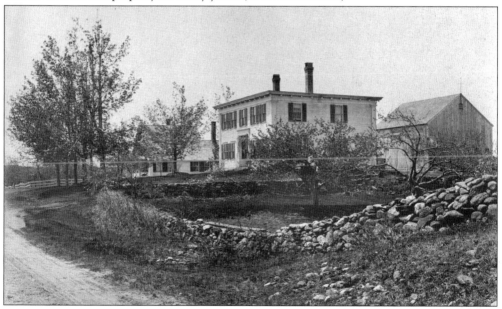

The Maples, at 45 Lanes Road, is an example of the townhouse style in the unique setting of a rural countryside. However, this area once had a busy chair factory located here. Jonas Merriam built the house in 1825 with careful attention to detail. Carved wooden acorns under the eaves are one example of his craftsmanship. The house was used for many years for summer boarders who came to enjoy the mountain air. It remains a private home today. (WHS Collection.)

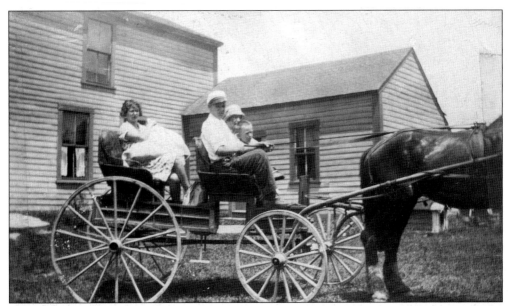

Toivo Tuominen is held by his mother, Hanna, while his father, Kustav, holds the reins. This photograph was taken *c.* 1920 in front of their home at 10 Harrington Road. The Tuominen family later moved to South Street, where Toivo operated an auto body shop in the barn. In 1946, he began serving as the Westminster police chief from his home. He retired in 1970. (Courtesy of Toivo Tuominen.)

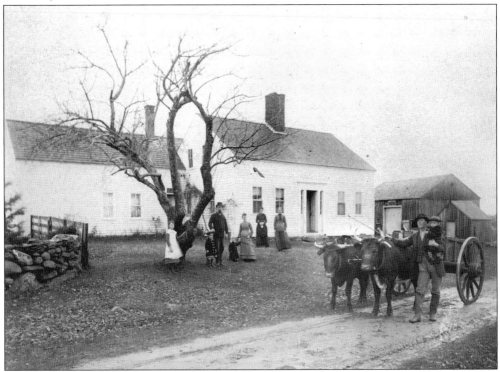

Standing next to the cart, Judson Foster Sr. is holding his daughter Katherine, who later married John Sargent, a successful businessman. (WHS Collection; donated by Ann Sargent.)

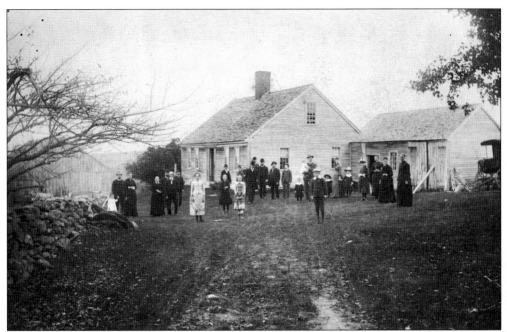

This house, at 197 Davis Road, was built in 1838 on the side of a hill and has an interesting pattern of rooms on different levels. The large gathering shown includes Katherine Foster, the small child in her father's arms. Her father, Judson Foster (grandson of Hannah Seaver), owned the house between 1903 and 1906. (WHS Collection; donated by Jeanette Sullivan and Charles Coolidge.)

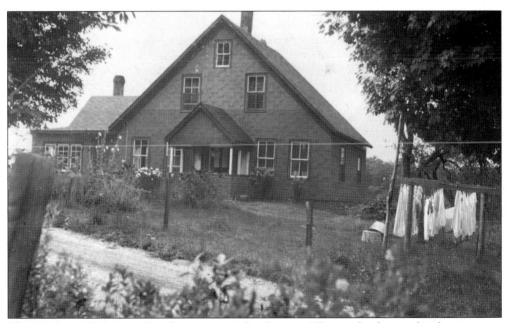

The home at 103 Minott Road sits near Cedar Swamp. The nearby forest of cedar trees was unusual in the area. Here, local farmers chased and killed the last wolf in the town. This 19th-century, Greek Revival vernacular house is now a private home. (WHS Collection.)

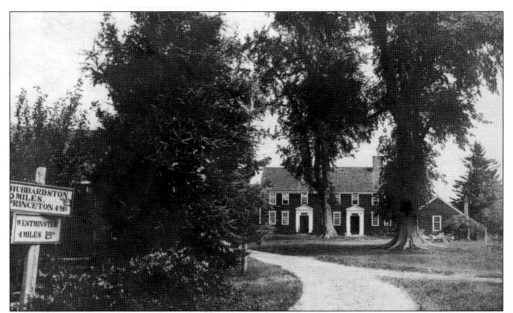

At 260 Davis Road, this home is the only one in Westminster lived in today by direct descendants of the original owner, Nathan Whitney. Whitney was a tax collector for King George III and also served as a captain in the king's militia. Captured Hessian soldiers were quartered here and helped plant the apple orchard on the farm. The home was built in 1752. (Courtesy of the Lane family.)

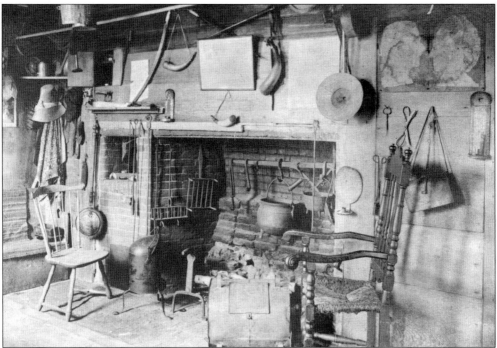

The kitchen in the earliest section of the Whitney Homestead is much like it was when the family used it in the 18th century. It took time to prepare meals over this fire. Bread baking was an all-day affair. (WHS Collection.)

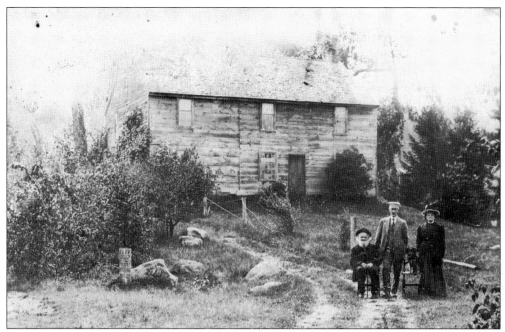

The house at the foot of Bolton Road and Mile Hill Road was known as the Fosket place. Samuel Weston settled here c. 1845. Hison Ambrose is seated in front of the homestead with guests. The house later became the Sitzmark, a local club, and burned in 1960. (WHS Collection; donated by Priscilla Page.)

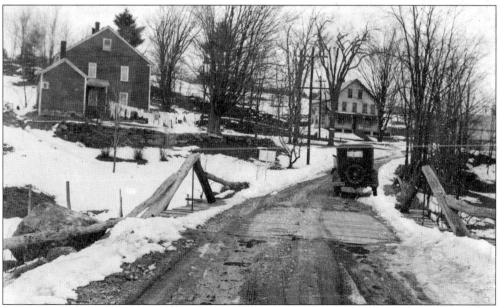

This road leads to the section of town called Whitmanville, ending up at Bragg Hill Road and 249 South Ashburnham Road. The old house on the right was probably built by the Merriam brothers to house the workers from their chair factory. It served as a country store c. 1900. The house in the upper left has been torn down. (WHS Collection.)

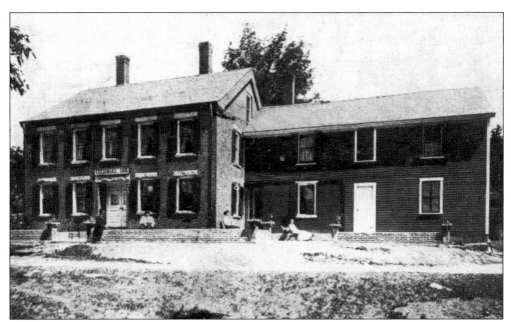

The Colonial Inn, at 10 Roper Road, was built c. 1836 by the proprietor, Edward Bacon. When the stagecoach stopped, travelers enjoyed rest and refreshment before continuing their journey. The Bacon family farmed this property from 1772 to 1891. Crocker Burbank purchased the house early in 1900 and later sold it to the Roper family. The Leavenworth family bought it in 1942 and ran a successful dairy farm until the 1960s. (WHS Collection.)

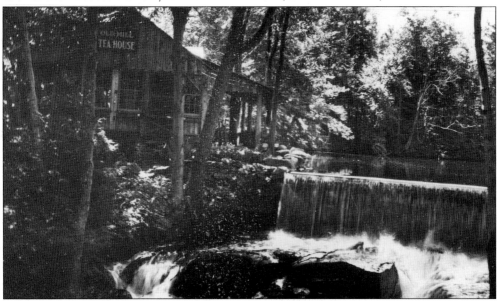

The site of the Old Mill was originally a sawmill built by Philip Bemis in 1761. It passed eventually to the Raymond family, which operated a number of industries here for more than 100 years, including the manufacture of organ pipes and wood shingles. In 1920, Raymond sold the mill to a Miss Keough, who operated a tearoom during the summer months. Ruth and Ralph Foster opened the Old Mill Restaurant in 1945; the family is still running this business that attracts visitors from all over the world. (WHS Collection.)

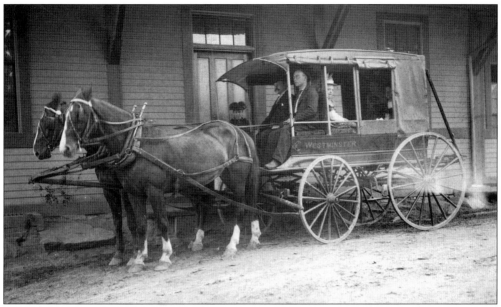

Edward R. Miller sits in the mail coach, which was also used as a passenger coach. Stagecoaches were an important part of the 19th century. Behind the coach is the Westminster Depot, which was located on old Depot Road, now Barthrick Road. (WHS Collection.)

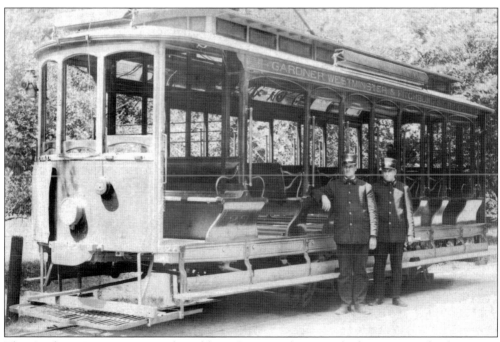

The Gardner, Westminster, and Fitchburg Street Railway was built in 1899. The fare was a nickel. The trolleys ran on a regular schedule from Waite's Corner in Fitchburg to the Westminster Hotel and on to Gardner. On summer weekends in the early 1900s, large trolley cars brought crowds from the region to Wachusett Park in Westminster. (WHS Collection.)

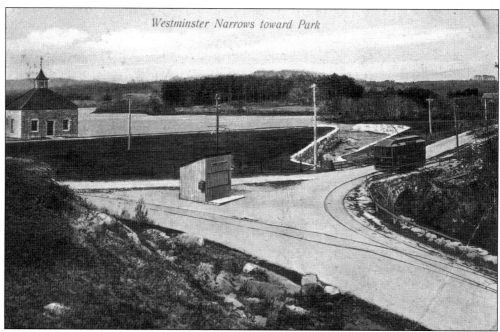

Westminster Narrows toward Park

It is hard to imagine a trolley turnaround in Westminster. At Wyman's Pond, where Narrows and East Roads meet, is a large area that looks like a quiet country corner. It was once a busy place, where commuters could catch a ride to work and school. One could even get out to Wachusett Park at the foot of the mountain. The trolleys began in 1900, and the stone house at the dam was built in 1901. (WHS Collection.)

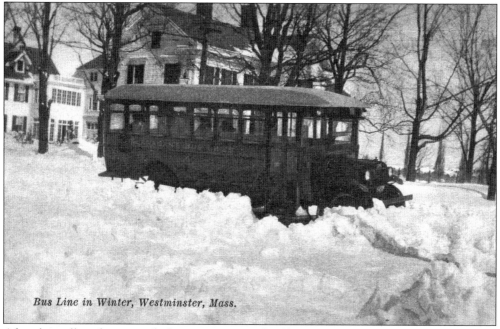

Bus Line in Winter, Westminster, Mass.

After the trolleys disappeared, there was a network of buses to carry residents to work, school, and play. With a higher elevation than its neighbors, this hilly town has always taken snow in stride. (WHS Collection.)

Station agent Daniel Burns flags down a train at the depot near the railroad bridge on Route 2A eastbound. The station was located on Depot Road, now Barthrick Road. (WHS Collection; donated by Beverly Lothrop.)

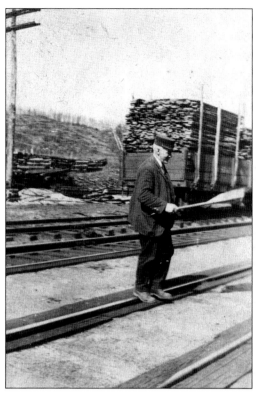

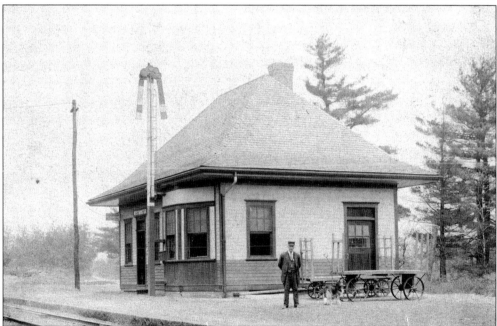

In the early 1900s, this depot was an important part of life for many people. Many products, especially grain, were delivered by train and sold at Merriam's store nearby. The stagecoach also picked up mail from here. Helen Merriam and her friends often walked to the depot to catch the train. The depot is now gone, and the train no longer stops in Westminster. (WHS Collection.)

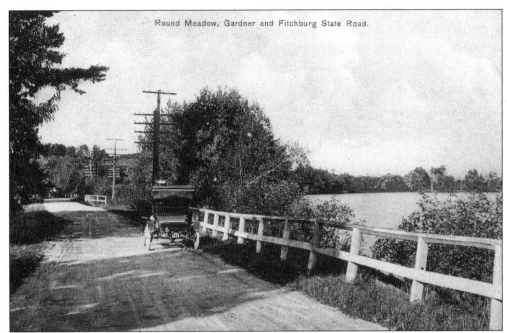

Caleb S. Merriam dammed the stream through Round Meadow to create waterpower for his sawmill. Merriam's granddaughter Helen later recalled that her family, in order to keep cool on hot summer nights, would row out and sleep in the small cabin that her father had built on the island in the middle of the pond. On warm evenings, fishermen cast their lines on the north rim and, in winter, braved the elements to ice fish. (WHS Collection.)

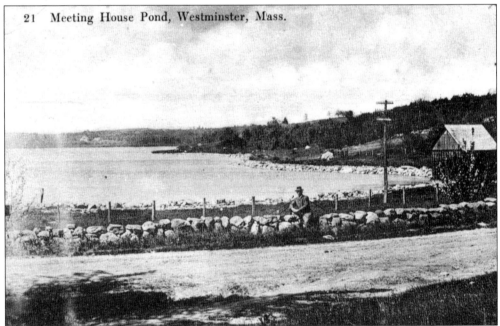

21 Meeting House Pond, Westminster, Mass.

The town's largest body of water, Meetinghouse Pond, is located on South Street only a half mile from the town center. This pristine, spring-fed pond is the drinking water supply for Westminster and Fitchburg. (WHS Collection.)

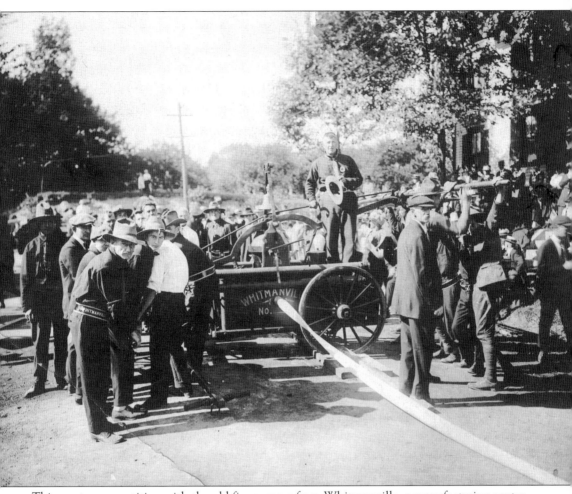

This muster competition with the old fire pumper from Whitmanville, a manufacturing center in the northern section of town, shows the excitement that these events create. Musters are still popular contests between fire departments. (WHS Collection; donated by William Wyman.)

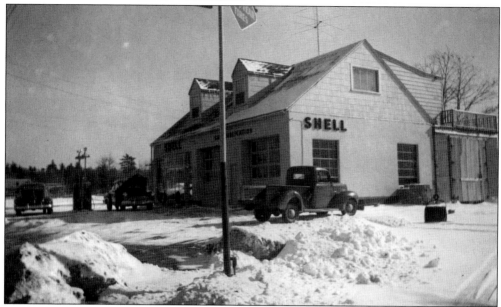

This Shell station was located on Route 2A near Holmes Park. It was operated by the Rahaim family. Family tradition says that Rahaim advertised that his gas station was open 24 hours a day, and he slept on a cot in the building so he could hear customers drive up. (WHS Collection.)

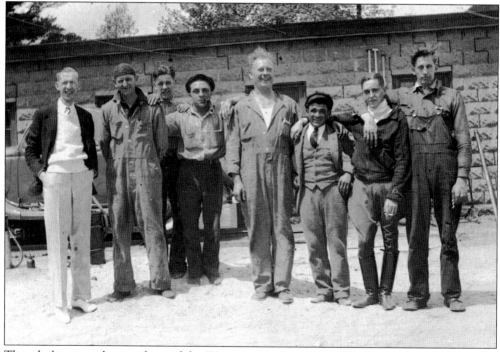

The whole gang is here in front of the Westminster Garage c. 1936. Shown, from left to right, are unidentified, Andy Anderson, unidentified, Albert Arcangeli, Andy Makela (owner of the garage), Giocondo Arcangeli, David J. Kempi, and Weikko (Jake) Leikkonen. The garage was operated by Robert Buckman for many years and is now owned by Jon K. Luoma. (WHS Collection; donated by Stazy Kempi.)

Three

FAMILY, FRIENDS, AND NEIGHBORS

Westminster has been a quiet, rural community of friends and neighbors who have worked, prayed, and played together. The downtown was always referred to as the Center, where residents congregated for shopping, socializing, and for town government functions. It had changed little until World War II.

Westminster's population has steadily grown over the years. Residents have included people who have served the town, the Commonwealth, and the nation. Among those residents were a U.S. Army general, a state senator, congressmen, lawyers, doctors, plumbers, blacksmiths, electricians, and farmers. At the beginning of the 1900s, Finnish, Italian, and French ethnic groups immigrated to Westminster and enriched the community. The fine schools and library demonstrate the commitment of the townspeople to the continual development of each individual's talents.

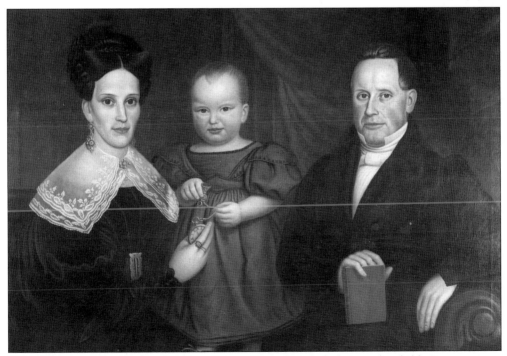

This Doty family portrait—showing Susan, Timothy, and their only child, Pearson—was painted c. 1834. Timothy operated a hotel and country store and lived at what is now 131 State Road West. He was a man of influence and held the position of selectman for five years. He died in 1835; his widow, Susan, later married Milton Joslin. A painting of Susan Joslin is in the Shaker Museum in Harvard, Massachusetts. (WHS Collection; courtesy of Forbush Library.)

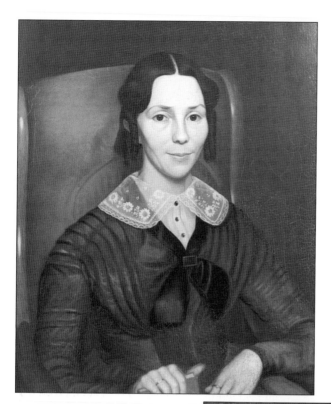

Nancy Spaulding Coolidge was the wife of Charles Coolidge. This portrait was painted by Westminster's famous primitive painter, Dea. Robert Peckham. (WHS Collection; courtesy of Forbush Library.)

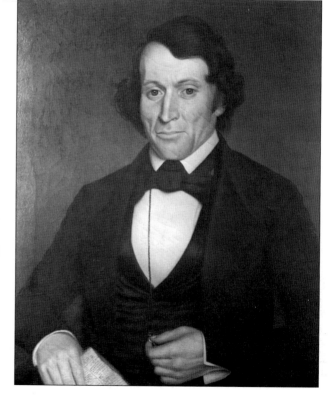

Charles Coolidge married Nancy Spaulding in 1831. Together they raised 10 children. He was a successful chair maker who began his business in a small shop near the Gardner line and later moved his business to the Bigelow Mill near the village in the rear of the Nichols Brothers factory building. This original portrait was painted by Peckham. (WHS Collection.)

Betsy Whitney Howard, the wife of Nathan Howard, was born in 1802, the daughter of Dea. David Whitney and Elizabeth Barron. They were the parents of seven children, including Albert Howard (1845–1931). She died in 1897. (WHS Collection.)

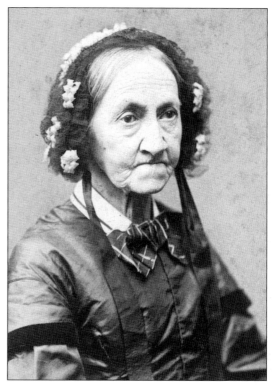

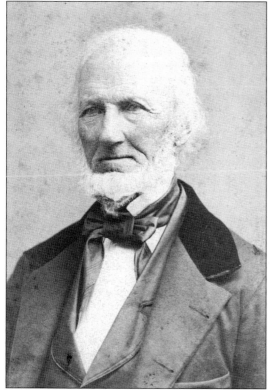

Nathan Howard was born in 1795, the son of Joseph Howard and Hannah Pollard. He married Betsy Whitney in 1822. Nathan, a man with a quiet dignified manner and exemplary habits and character, lived in the family homestead on Academy Hill at 3 Foster Street. (WHS Collection.)

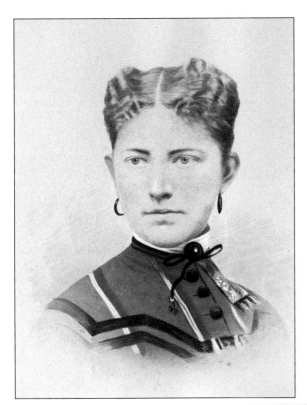

Mary Abby Forbush was a member of the family that gave Westminster its beautiful library in 1901. Born in 1847, she was the only child of Joseph and Abbie Forbush. The Forbush Library was given to the town by Charles A. Forbush in memory of his cousin Joseph, Mary's father. (WHS Collection; donated by M.A. Ware and Sarah H. Whitman.)

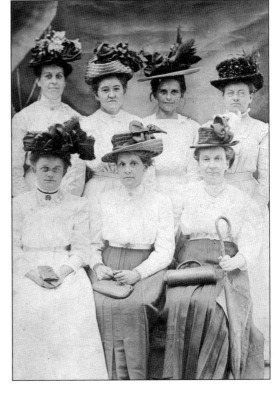

The hat industry flourished in the early 1900s in Westminster, and these young women are probably modeling local creations. Cottage industries may also have produced the pocketbooks, umbrellas, and other accessories shown in the picture. Doris Fenno is in the front row, center. Gertrude Gilson is in the back row, second from the left. (WHS Collection; donated by Robert Mason.)

Portrait painter Robert Peckham was born on September 10, 1785, and died on June 29, 1877. He married Ruth Sawyer of Bolton in 1813 and came to live in Westminster in 1820. He built the house at 12 Academy Hill and raised nine children there. Peckham was a very active citizen of the town and served as deacon of the First Congregational Church for 14 years. (WHS Collection; donated by Leon Whitney.)

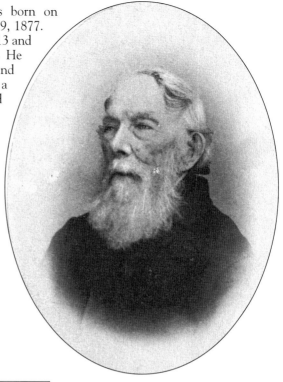

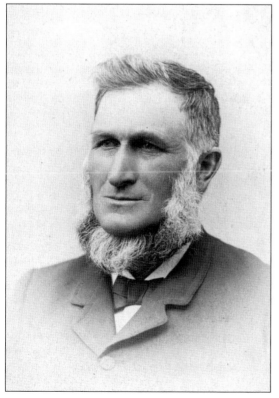

Charles Hudson was the author of the 1832 *History of Westminster*. He was the pastor of the First Universalist Church (now the American Legion Hall) on Main Street. He also served as a state assemblyman (1828–1833), state senator (1833–1839), and national congressman (1841–1849). (WHS Collection.)

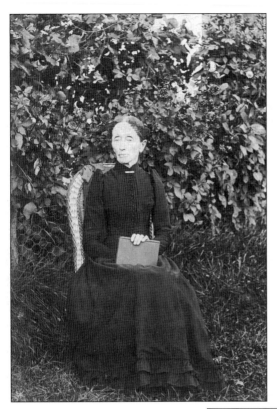

Sarah Amelia Hager Upton, the daughter of Elijah and Mary (Jones) Hager, was the wife of Charles Upton. The Hagers lived on the Hobart Raymond homestead, formerly the home of Edmund Bemis, and in 1820 purchased the Edgell farm. Hager Park, located on Route 140, was a gift to the town by her brother Joseph. (WHS Collection.)

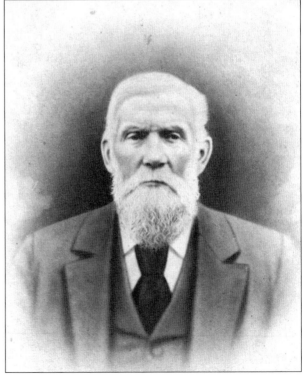

Charles Upton was born in 1821, married Sarah Hager in 1845, and lived in the house at 33 Bacon Street. He was a mason by trade and a member of the board of selectmen in 1859 and 1860. He taught vocal music and led the choir of the Universalist church. The Uptons had three children—George, Charles, and Lillian. Lillian donated funds for the construction of the Upton School. (WHS Collection.)

These women dressed in Japanese fashion were waitresses at a Japanese tea at the First Baptist Church on Main Street *c.* 1883. They are, from left to right, Jennie Gilson, Cora Merriam, Ida Simonds, Eliza Baker, Maria Partridge, and Iona Tottingham. (WHS Collection; donated by Dorothy Young Slade.)

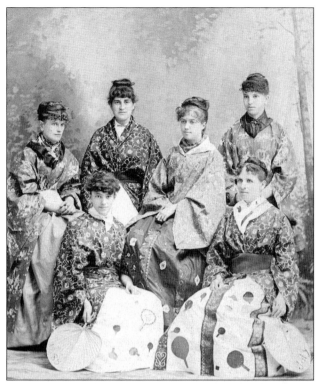

Charles Eaton and Maud Butterfield Eaton are shown with their children Herman and Ruby. Eaton was born in 1854 and was the fourth generation of his family to live in Westminster. Charles was a chair maker in the western part of the village. (WHS Collection; donated by the estate of Ida Eaton.)

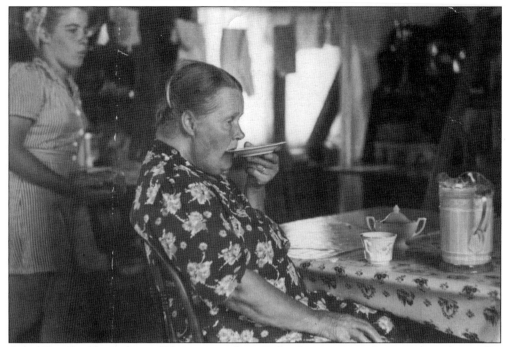

Anna Kamila, who came to Westminster from Finland in 1919, is shown sipping her coffee from a saucer. It is a Finnish custom to sip coffee through a sugar cube held in the lips. (Courtesy of Irene Kamila.)

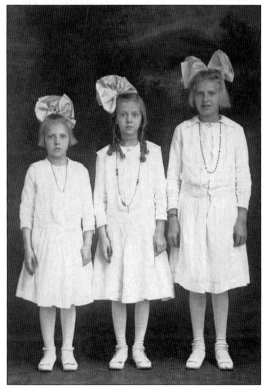

The Kaarela sisters were a fashion statement in their giant bows c. 1930. Seere, Ina, and Hilda were the children of Matti and Senja Kaarela. The family name was changed from Kaarelela when Matti immigrated from Finland to the United States and settled on Worcester Road. (WHS Collection; donated by Christine and Francis Trainque.)

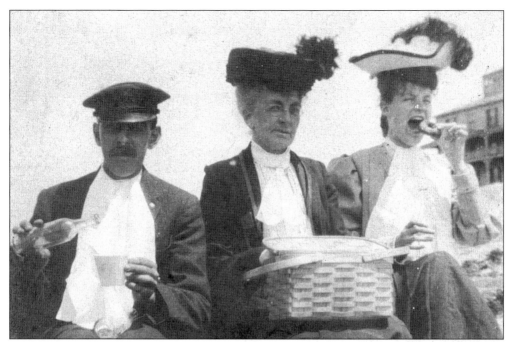

This family enjoys a picnic on Wachusett Mountain, a popular resort destination since the 1800s. The Summit House on top of the mountain (in the background) had a restaurant and gift shop. (WHS Collection.)

These young men enjoy an outing at Wachusett Park. The second man from the left is Lester Kelty and the last man on the right is Ed Young. (WHS Collection; donated by Betty Aveni.)

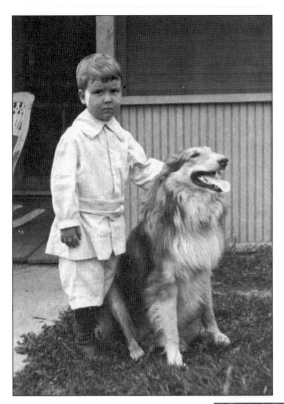

Francis E. Coombs was four years old when he posed with his pet collie. He was born in 1914, the son of Jesse and Florence Coombs, and spent most of his childhood on Nichols Street. In 1939, he married Eva Gage, one of 12 children of Franklin Gage, who lived at Depot Road and Route 2A. Coombs was employed at Simplex Time Recorder. (WHS Collection; donated by Eva Coombs Lord.)

Janet Elizabeth Battles took advantage of a local vendor who came through town and sold rides on his Shetland pony. The vendor also took pictures of the children for their parents. Battles lived on Main Street for a number of years. (Courtesy of Janet Battles Perret.)

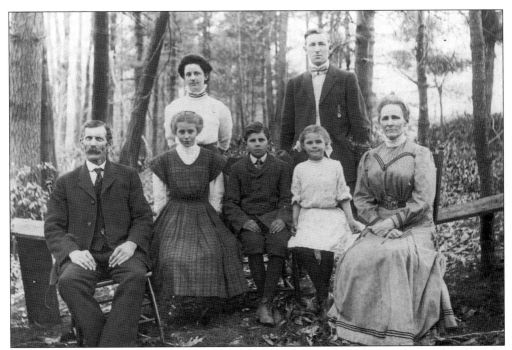

Members of the Alton and Emma Cummings Battles family are, from left to right, as follows: (front row) Alton, Dorothy, Herbert, Hester, and Emmare; (back row) unidentified and Roger. Alton Cummings was born in Westminster in 1853 and lived on the Round Meadow Farm that was originally owned by his grandfather, Maj. Nathan Raymond. The farmhouse is located at 23 Battles Road. (Courtesy of Janet Battles Perrett.)

Edwin, Mildred, and Harold Muhonen sit in a wagon next to the old crank gas pump while enjoying their soda pop. (Courtesy of Mildred Lindroth.)

Jesse Coombs enjoys driving his car. Jesse and Florence Coombs came to Westminster in 1913. Jesse had served in the Civil War and later became the superintendent of the prison camp on Wachusett Mountain. When the camp closed in 1916, he moved his family to the house on Nichols Street, formerly owned by Francis Nichols. (WHS Collection; donated by Eva Coombs Lord.)

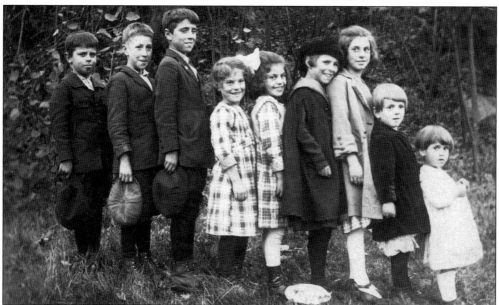

The Goguen cousins and a friend shown in this 1918 photograph are, from left to right, Arthur, a friend, Herve, Lillian, Ella, Lily, Evelyn, Alice, and Doris. This photograph was taken at 137 Narrows Road. All ages and sizes often played together. After a day of running around the yard and playing hide-and-seek, they went across the street to Wyman's Brook to take a bath. (Courtesy of Lillian Goguen Williams.)

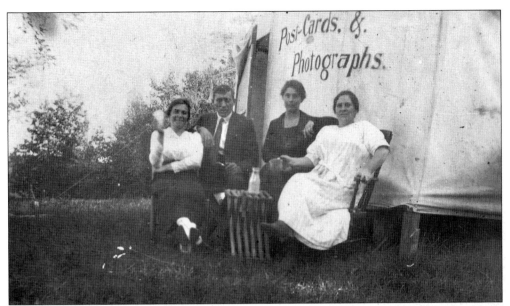

For many summers, the Babineaus set up their tent behind the Goguen residence at 137 Narrows Road to take photographs. Shown, from left to right, are Alvida Babineau, her husband, her sister, and Vitaline Melanson Goguen. In 1915, you could have your photograph made into a postcard. With two mail deliveries every day, the postcard could be sent in the morning and answered that afternoon. (Courtesy of Lillian Goguen Williams.)

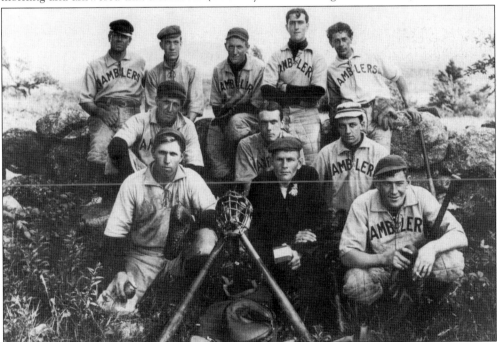

The players on this c. 1920 Westminster Ramblers baseball team are, from left to right, as follows: (front row) unidentified, coach Ed Young, and unidentified; (middle row) Roger Battles, Charlie Towle, and unidentified; (back row) Herbert "Bob" Battles, unidentified, unidentified, Lester Kelty, and unidentified. (WHS Collection; donated by Betty Aveni.)

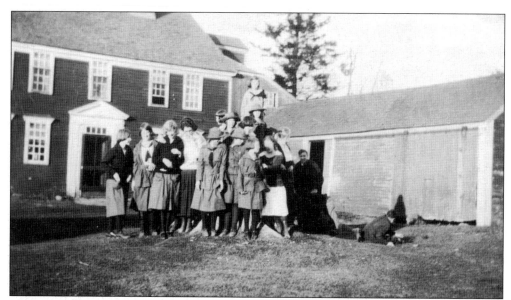

This Girl Scout troop outing was held at the Whitney Homestead. The first Girl Scout troop in Westminster was formed in 1923 and was led by Barbara Fenno, Harriet Smith, Doris Gilson, and Helen Dawley, who are also shown. (WHS Collection.)

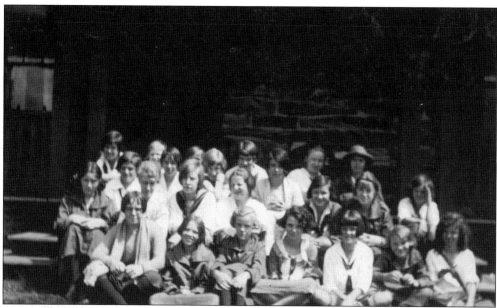

Members of the Clover Leaf Girl Scout Troop No. 1 are shown at a meeting in 1924. From left to right are the following: (front row) unidentified, Annie Walker, Evelyn Humphrey, Mary Turner, Celia Rice, Lois Walker, and Mary Cummings; (middle row) Lucille French, Annabel Dawley, Mary Smith, Lana Williams, Edna Hurd, Mildred Humphrey, Ellen Cummings, Bernice Rowe, unidentified, Evelyn Hicks, and unidentified; (back row) Pearl Stockwell, Harriet Roper, Velma Flagg, unidentified, Marion Roper, and unidentified. (WHS Collection; donated by Mildred Puranen.)

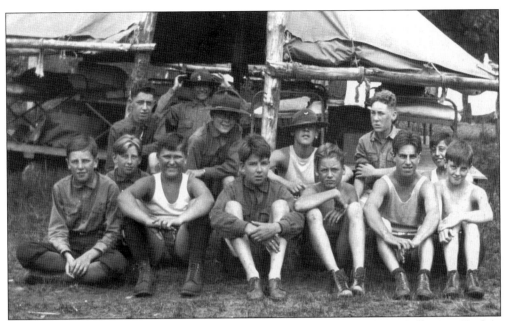

This Westminster Boy Scout troop poses in front of their tent at Camp Collier in Gardner c. 1926. The Boy Scouts organization in Westminster is believed to have been started c. 1915, but no records were kept until 1922. (WHS Collection; donated by Eva Coombs Lord.)

The United Cooperative Youth Group was active in Westminster through the 1920s. Although its origins were with the Finnish cooperative movement, the group encouraged others to join in its activities. Here, the group prepares for a conference at UMass. (Courtesy of Betsy Hannula.)

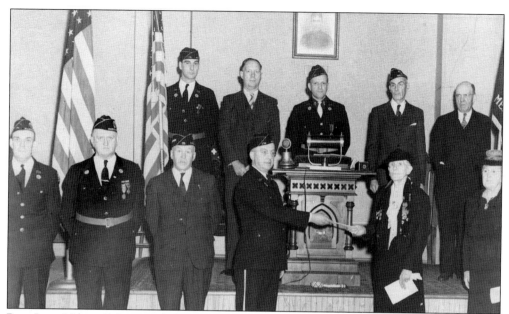

Rev. Lucy Milton Giles passed the Universalist church building deed to the American Legion as a gift. Shown during the ceremony are, from left to right, the following: (front row) Raymond Stockwell, Harold Towle, Emory Raymond, Arthur Rice (accepting gift), Reverend Giles, and Laura Miller; (back row) Howard Smith, unidentified, Comdr. Walker Brown, Harry Howard, and William Shay. (WHS Collection.)

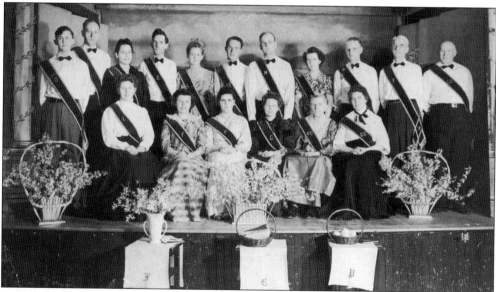

Members of the Westminster Grange wore their regalia for the installation ceremonies held on the stage of the second floor in the town hall *c.* 1940. Shown, from left to right, are the following: (front row) Ruth Warner, Miriam Mela, Betty Kelty, Ruth Butterfield, Universalist minister Lucy Milton Giles, and Mabel Gleason Story; (back row) Eddie Bilson, Jalo Snellman, Ida Barrett, Congregational church minister Marion Phelps, Elaine Nikki, Thomas Luoma, school principal Charles Warner, Betty Conant, Allen Holmes, Edward Terrill, and Emory Raymond. (WHS Collection.)

Four

GROWING UP

For almost 200 years, children in Westminster were educated in one-room schoolhouses close to where they lived. By 1790, there were 12 district schoolhouses scattered throughout town, usually at intersections of well-traveled roads. The first schoolhouse in the center of town was built on the common in 1789. In 1818, a brick school was built on the same spot. A school committee of three people was responsible for every aspect of schools until 1890, when the first superintendent of schools, Flora E. Kendall, was hired. In the earliest days, there were no standard qualifications for teachers, and the school committees found it difficult to fill positions with people who had even graduated high school. The teachers were often not much older than the oldest students, and maintaining good discipline was difficult.

It was expensive to maintain many different schools. In 1898, it was voted at town meeting to close all schools with less than 10 pupils. This did not happen immediately, however, and the last district schoolhouse finally closed in 1934. After that time, all students were educated at the Center School (built in 1855), the Upton School (built in 1912), and the Loughlin School (built in 1935).

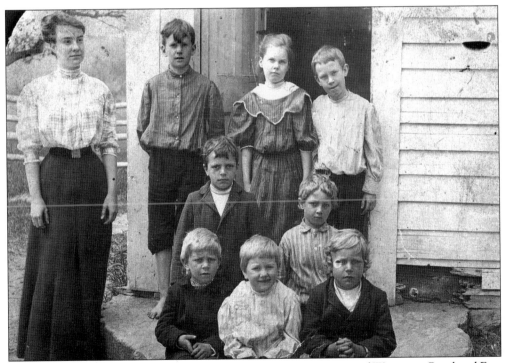

The Lake Street District Schoolhouse No. 7 was at the intersection of Worcester Road and East Road. Shown, from left to right, are the following: (front row) three unidentified; (middle row) Orrin Brigham and unidentified; (back row) teacher Sadie Rice, Carl Page, Annie Page, and Albert Page. (WHS Collection; donated by Priscilla Surrey Page.)

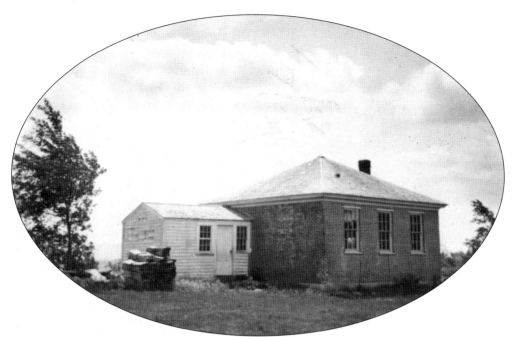

The District Schoolhouse No. 9, called the North Common School, was built in 1821 on the southeast corner of the Syd Smith Road and North Common Road intersection. It replaced an earlier schoolhouse in this neighborhood built in 1773. This brick schoolhouse was paid for by the residents of the North Common rather than the town and was used until 1928. It was demolished by the Hurricane of 1938. (WHS Collection.)

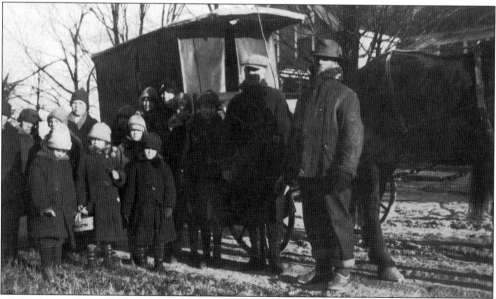

Children usually walked to school. When there were too few students to support a district school, children from outlying parts of town were transported to the Center School by a barge. A barge was a specially outfitted wagon with canvas walls. In winter, the wagon was placed on a sleigh. This photograph shows Lempi Tuomi with other schoolmates gathered next to the school barge c. 1925. (Courtesy of Betsy Hannula.)

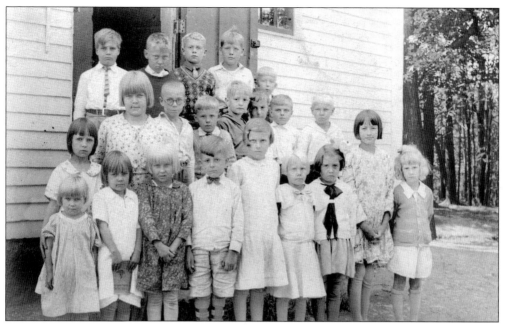

District Schoolhouse No. 2, built in 1798 at the intersection of South Ashburnham and Whitmanville Roads, held grades one through four in 1932. Known to be in the photograph are Aune Luomala, Velma Luomala, Anna Sherman, Walter Viewig, Agnes Adams, Irene Salo, Lillian Collette, Margie Reynolds, Eva Luomala, Aili Waltanen, Arthur Reynolds, Water Engman, William Parnanen, Arthur Codding, Charles Adams, Eero Luomala, Wilho Mayranen, Tauno Nappila, Kenneth Reynolds, Arthur Friberg, and Auri Sellman. (Courtesy of Wilho Mayranen.)

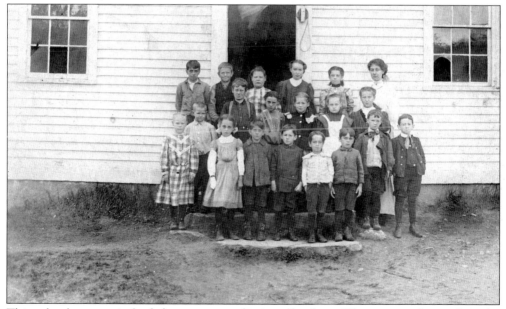

This school was typical of the one-room district schools in Westminster. Located in the southwest part of the town, it serviced those who lived in the area bordering Hubbardston to Gardner. (WHS Collection; donated by Robert Havener.)

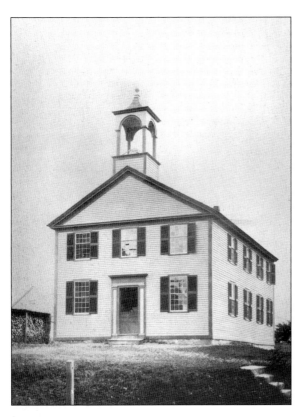

Westminster Academy was built in 1830. Students came from all over New England and boarded with nearby families. The number of students applying to the academy declined when neighboring towns began to provide a high school curriculum for older students. The academy closed in 1871, and the property and academy building were transferred to the town. The building served as a high school until it burned in 1888. (WHS Collection.)

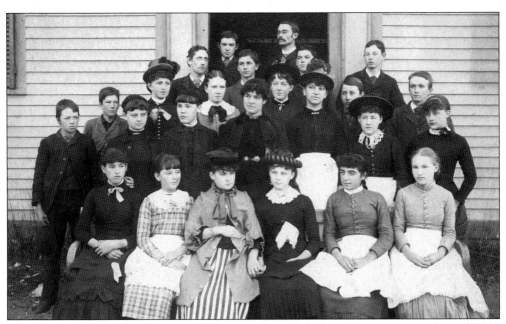

The Westminster Academy class in 1885 was made up entirely of Westminster students. (WHS Collection; donated by Leon M. Simonds.)

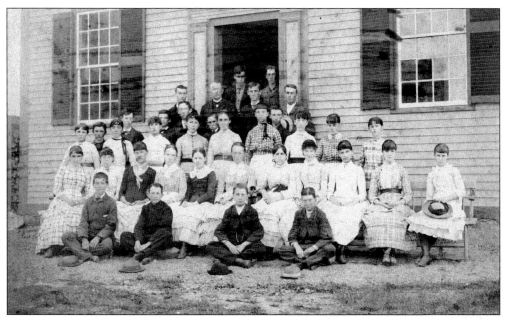

This class is standing in front of Westminster Academy. The principal of the high school was Lucas Baker, a teacher and principal in Westminster from 1910 to 1921. (WHS Collection.)

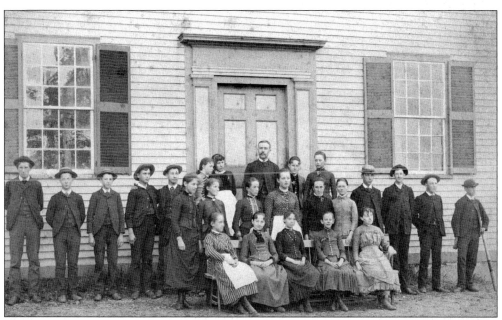

This class poses proudly in front of Westminster Academy sometime between 1871 and 1887. In 1865, the town began to pay tuition for Westminster students to attend the academy. After 1871, all Westminster students of high school age went to school in the old academy building. The fellow on the right with the baseball bat shows that the game of baseball had arrived in Westminster by this time. (WHS Collection.)

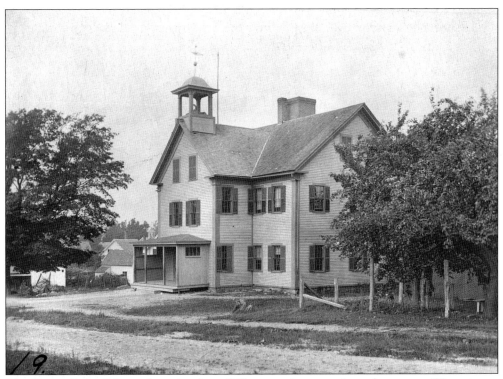

The Center School, located on Academy Hill across the street from the present Westminster Elementary School, was built in 1855 and was originally a one-story building. After Westminster Academy was destroyed by fire in 1888, a second story was added to the Center School to accommodate high school students. It was described in Tolman's *History of Westminster* as "a commodious, well-proportioned structure, an ornament to the village, and an honor to the town." (WHS Collection.)

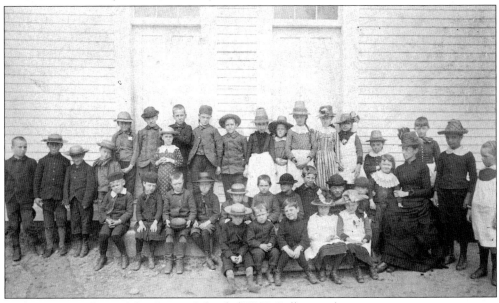

A class poses in front of the Center School. (WHS Collection.)

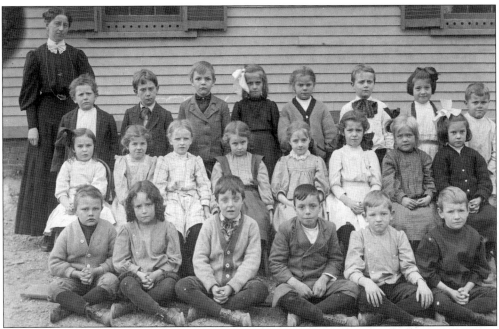

This was a primary-grade class at the Center School. (WHS Collection; donated by Mrs. Moran.)

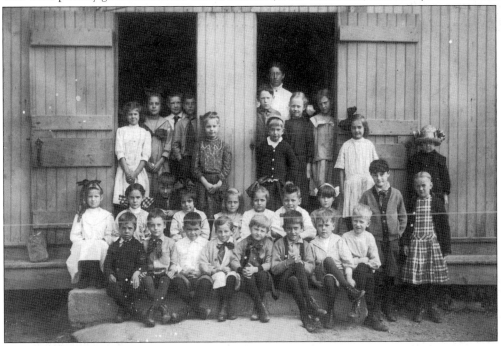

Teacher Helene Peter led this primary class at the Center School. Shown, from left to right, are the following: (front row) Edgar Bradbury, Coliss Eaton, Cornelius Hurley, Howard Clark, unidentified, Richard Conant, Adelbert Miller, and Harold Tofelt; (middle row) Priscilla Surrey, Louise Vincent, James Adams, unidentified, Celia Bjourson Blaney, Barbara Smith, unidentified, Edna Holmes, unidentified, and Martha Cedar; (back row) all unidentified. (WHS Collection; donated by Priscilla Surrey Page and Mrs. Moran.)

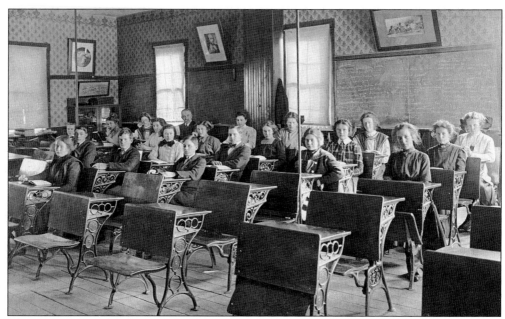

This is a Center School Class *c.* 1900. In the third row from the right at the third desk is Carl Sargent, who later served in both world wars. (WHS Collection; donated by Phillip Hills.)

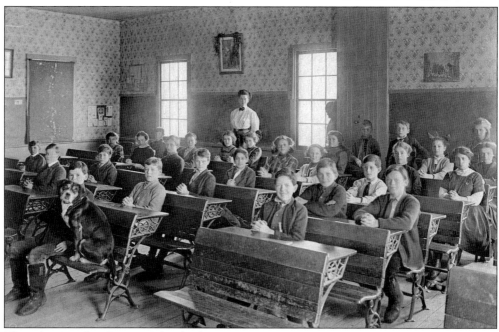

This class at the Center School, shown *c.* 1911–1912, was a combined class of grades five and six. The teacher was Agnes Howe Mansur. (WHS Collection; donated by Ellen Harrington Mason.)

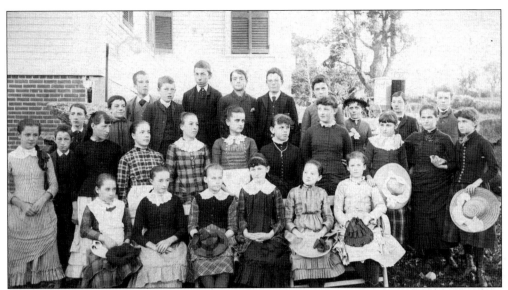

A Center School class is shown c. 1885. Those in the front row are, from left to right, Edna Shephard, Roella Partridge, May Hutchinson, Florence Derby, Laura Eaton, and Grace Nichols. The others are unidentified. (WHS Collection; donated by Jessie Adams.)

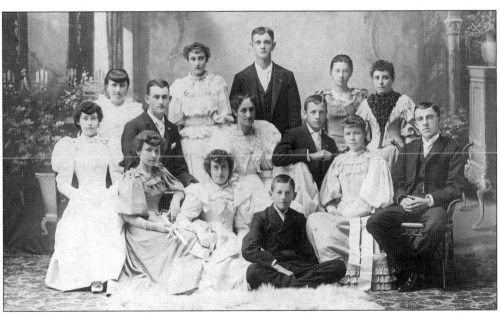

The members of the Westminster High School Class of 1894 pose here. Known to be in the photograph are Frank Merriam, Eva Merriam, Grace Merriam, Maude Lucas, Etta Sheila Gorman, Isabelle Roper, Tom Cody, Gertrude Sprague, Edward Rice, Lester Lynde, Rose Spaulding, Walter Sawin, and teacher Annie Plummer. (WHS Collection.)

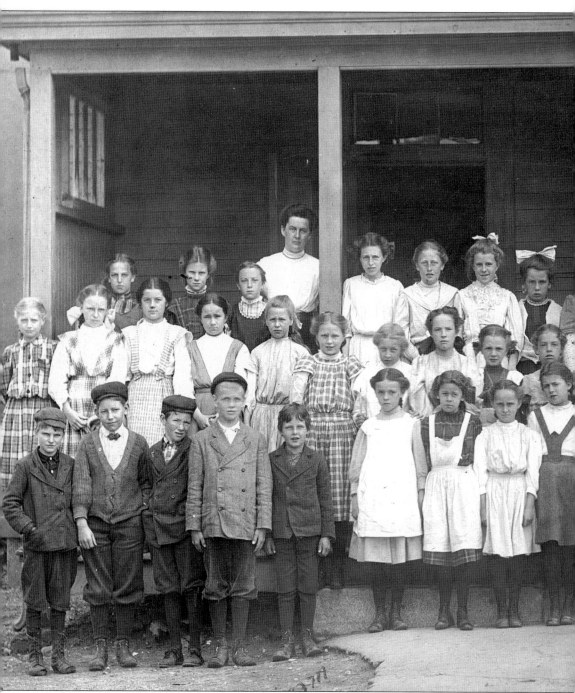

These were the intermediate classes at the Center School in 1910. The students are, from left to right, as follows: (front row) Allen Holmes, Oswald Putnam, Rudolph Tofelt, Lloyd Hardy, Albro Putnam, Carmen Houghton, Ruth Derby, Beatrice Ham, Alice Fenno, Henrietta Vier, Grace Stone, Mildren Fisher, Merton Sawin, Edgar Rummery, Charles Towle, Herbert Battles, James Holmes, Roy Stockwell, William Holmes, Charles Hodge, and Richard Stanbridge; (middle row) Ada Hicks, Edith Rummery, Sarah Kelty, Alice Wells, Florence McKay, Florence

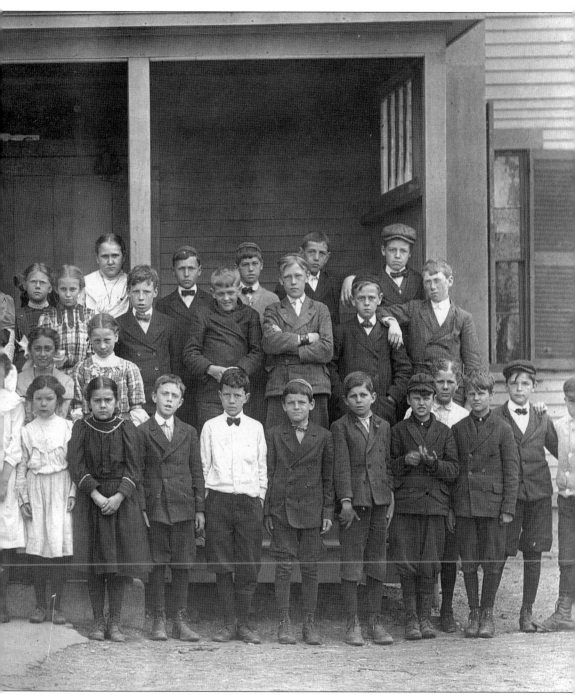

Black, Gladys Young, Stella Seaver, Alma Murdock, Ellen Harrington, Hazel Ham, Ethel Withington, Yetti Maki, unidentified, Ralph Young, unidentified, and Frank Hardy; (back row) Marguerite Jacobs, Katherine Foster, Adelaide Whitney, teacher Agnes Mansur, Rhoda Viner, Ruth Donaldson, Elsie Hodge, Eva Legey, Iona Ela, Lois Sawin, Dorothy Battles, Ida Eaton, Henry Miller, Spencer Merriam, Norman Hardy, and Paul Derby. (WHS Collection; donated by Ellen Harrington Mason.)

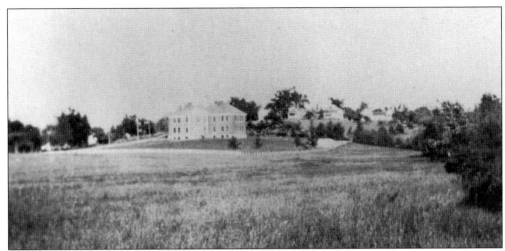

The Upton School was built in 1912 to relieve overcrowding in the Center School. There were more than 50 children in each class. At that time, there were no other school buildings on this site. The land was donated to the town by Frank W. Fenno in memory of his wife, Mary Nichols Fenno. In addition to the funds the town appropriated, George and Charles Upton donated funds to build the school. (WHS Collection; donated by Robert Mason.)

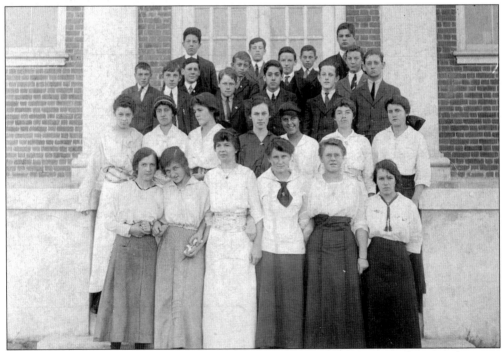

The students from Westminster High School known to be in this photograph are Ruth Burns, Martha Horin, Alma Murdock, Beatrice Ham, Lois Sawin, Faye Hurd, Ruth Darby, Helen Willis, Barbara Fenno, Gertrude Jennie Erickson, Ellen Harrington, Alice Fenno, Harold Whitney, Godfrey Rowley, Philip Vincent, Robert Dearborn, Miles Harrington, John Hoover, Richard Stanbridge, Herman Knower, Charles Towle, Francis Bell, Edgar Rumery, Harry Clark, Jamer Hoover, and Leonard Roby. (WHS Collection; donated by Beverly Lothrop.)

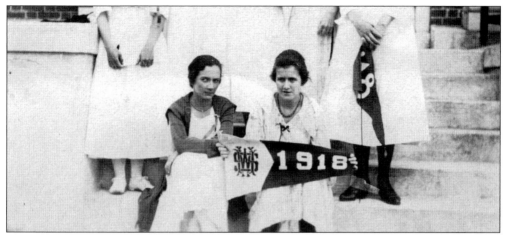

Ruth Handlin and Barbara Fenno sit with the banner of Westminster High School in 1918. As the student population grew, more classroom room was needed. In 1928, the town voted (70 to 69) to close the high school and convert the rooms for elementary students. For the next 30 years, Westminster residents paid tuition and transportation for high school students to attend either Gardner or Fitchburg High School. (WHS Collection; donated by Beverly Handlin Lothrop.)

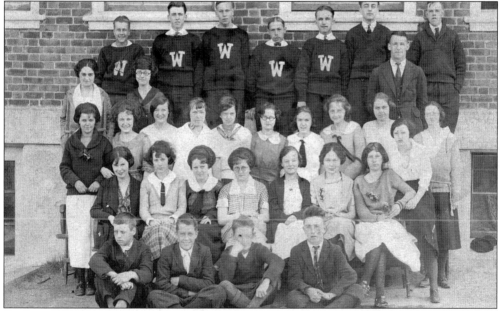

Students of Westminster High School in 1923 include, from left to right, the following: (first row) Herman Vincent, Harold Roper, Henry Carpenter, and Willard Gates; (second row) Eleanor Sanderson, Helen Dawley, Edna Sunne, Dorcas Sawin, Anna Kahkola, unidentified, Martha Leino, and Lillian Page; (third row) Doris Cummings, Lena Curtis, unidentified, Ellen Hayden, Priscilla Surrey, Edith Holmes, Marion Murdock, Ellen Lehtinen, Ella Smith, Edna Hurd, and Rachel Hurd; (fourth row) teachers Louis Harding, Janet Howard, and Irving Sherwood; (fifth row) Porter Dawley, Paul Mansur, Tauno Halfors, Eero Rostedt, Toivo Hemmi, Lee Bracket, and Adelbert Miller. (WHS Collection; donated by Priscilla Surrey Page.)

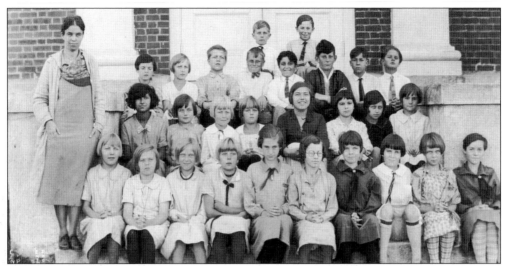

An Upton School class from c. 1927 includes, from left to right, the following: (first row) Irene Nisula, Aune Nappair, Helen Wintturi, Anna Kempi, Barbara Howard, Gwendolyn Chase, Olive Coombs, Betty Conant, Toini Laitinen, and Marion Earle; (second row) Mary Arcangeli, Adele Husari, Aino Keskinen, unidentified, Lily Kempi, Elsie Whitney, Laura Vincent, and unidentified; (third row) unidentified, Aili Hintala, Urho Sakkinen, Ralph Mansur, Peter Arcangeli, Bruce Shannon, unidentified, and Edgar Holmes; (fourth row) Vernon Tuttle and unidentified. Standing to the left is teacher Dorothy Glacier. (WHS Collection.)

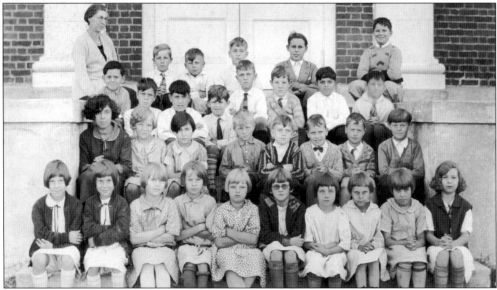

A class from the same school c. 1925 includes, from left to right, the following: (first row) Louise Ist, Lois Rinquist, Julia Jalava, Rhea Jaskelainen, Elma Hyvarinen, Phyllis Young, Anita Husari, Josey Skorko, Katherine Smith, and Florence B.; (second row) Antonette Arcangeli, Helvi Winturri, Christine McAdams, Martin Janhunen, Lester Kelty, Carl Mansur, Roy Mansur, and Eli Kahkola; (third row) Charles Skorko, Hugo Wilson, Leon McAdams, Harold Maggs, Roland Smith, Bruce Carpenter, Dante Arcangeli, and Warren Tabbot; (fourth row) teacher Mrs. Shannon, Waino Sakkinen, Reino Wasara, Ernest Wilson, Raymond Ploss, and Clifton Goodridge. (WHS Collection.)

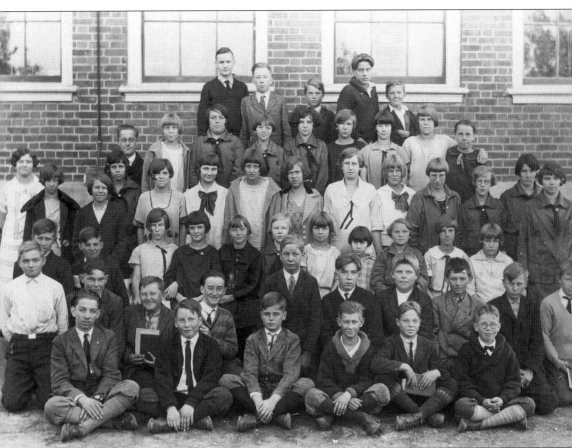

There were 54 students in Evelyn Haven's class of seventh- and eighth-graders in 1927. Note that several girls are wearing Girl Scout uniforms. From left to right are the following: (first row) Wendell Nye, Richard Mansur, Byron Smith, unidentified, Ernest Lehtonen, and unidentified; (second row) unidentified, Wilho Nygard, Tenho Napari, unidentified, unidentified, Charles Merriam, Howard Winter, Arthur Holm, Toivo Jaaskelainen, and unidentified; (third row) Weikko Lakkinen, Ernest Viewig, Irma Smith, Celia Rice, Ellen Kahkola, Harriet Roper, Elsie Heimo, Lois Walker, unidentified, Marion Turner, and Aune Lehtonen; (fourth row) teacher Evelyn Haven, unidentified, Gertrude Kaustinen, Martha French, unidentified, Ellie Stromberg, Taimi Lamsa, four unidentified students, ? Lakkinen, Alfreda Humphrey, and Lucille French; (fifth row) Donald Towle, Annie Heimo, Maude McGee, Annie Walker, Mary Turner, Rachel Aho, unidentified, Rachel Kaustinen, and Marie Wirtanen; (sixth row) Howard Morse, Clarence Roper, Paul Smith, unidentified, and Eino Ruostari. (WHS Collection; donated by Thaddeus Fenno and Martha Savage.)

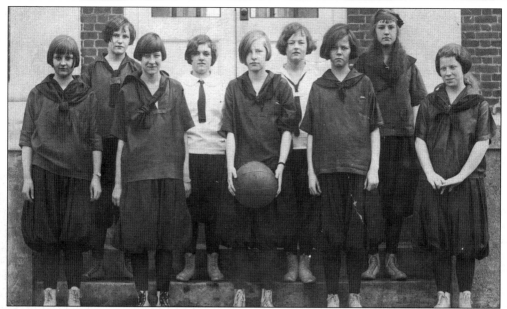

The first Westminster High School girls' basketball team was created in the 1925–1926 school year. On that team were, from left to right, the following: (front row) Kaino Krans, Elma Kahkola, Mary Smith, Ilmi Koski, and Laura Williams; (back row) Elmi Hill, Bernice Rowe, Anna Kahkola, and Mildred Humphrey. (WHS Collection; donated by Mildred Puranen.)

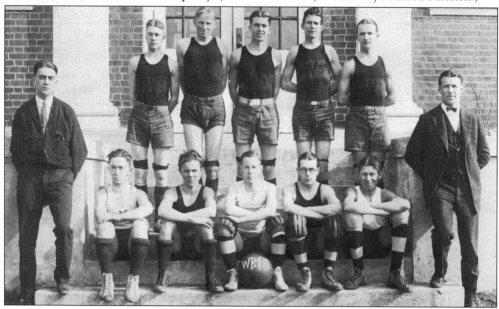

High school basketball was first introduced in the winter of 1922–1923 for boys. The team members ran from the Upton School to the town hall, where they practiced and played on the second floor. This is the team of 1924–1925. From left to right are the following: (front row) teacher Lee Brackett, Willard Gates, Arthur Williams, Gordon Humphrey, Thayer French, unidentified, and teacher Irving Sherwood; (back row) Porter Dawley, Marshall French, Paul Mansur, Harold Lawson, and Toivo Hemmi. (WHS Collection; donated by Gordon Humphrey.)

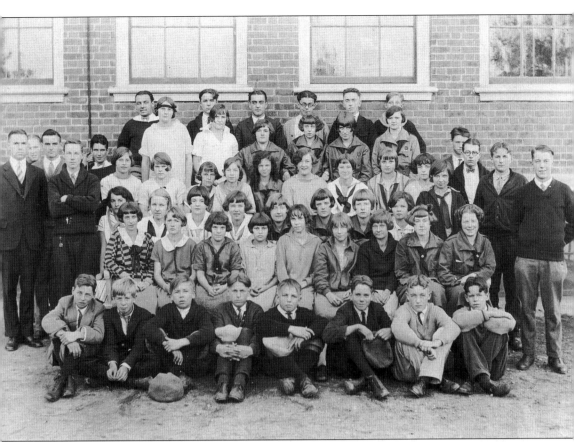

The Westminster High School Class of 1926 includes Herman Vincent and Harry Carpenter (first row, first and seventh from the left), Mildred Humphrey and Laura Williams (second row, seventh and eighth from the left), Marion Roper and Mary Smith (third row, second and seventh from the left). (WHS Collection; donated by Gordon Humphrey.)

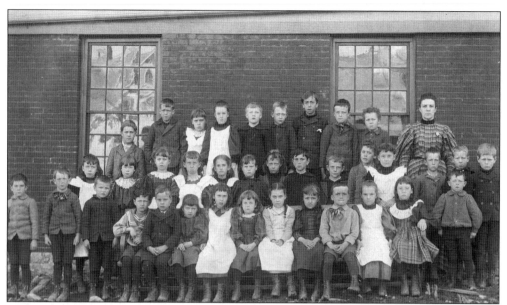

The Upton School became overcrowded very soon after being built. Every year, the school committee had the difficult task of placing each class. Sometimes they opened up a district schoolhouse that had previously been closed and required students in that neighborhood to attend there. In addition, in the 1926–1927 school year, classes were held at the town hall for these third- and fourth-grade students. (WHS Collection; donated by Robert Havener.)

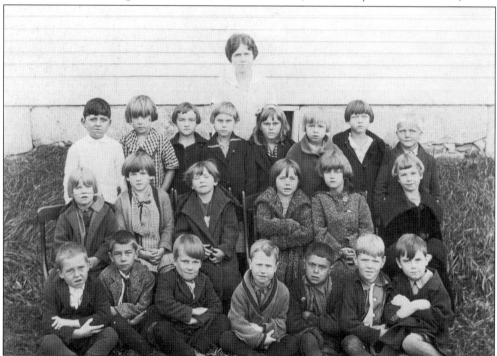

In the 1926–1927 school year, conditions were so crowded at the Upton School that all first-graders attended Doris Fenno's class at the Baptist church on Main Street. (WHS Collection; donated by Thaddeus Fenno.)

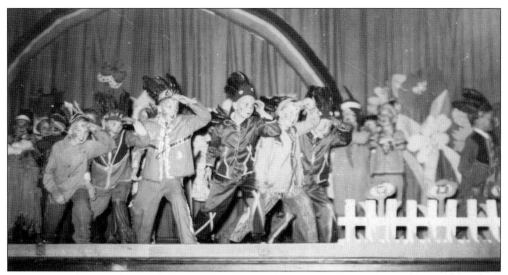

The new Loughlin Junior High School had a gymnasium with a small stage at one end. The stage was used for all kinds of activities. Here, a school class is presenting a program about Native Americans. (WHS Collection; donated by Fraser Noble.)

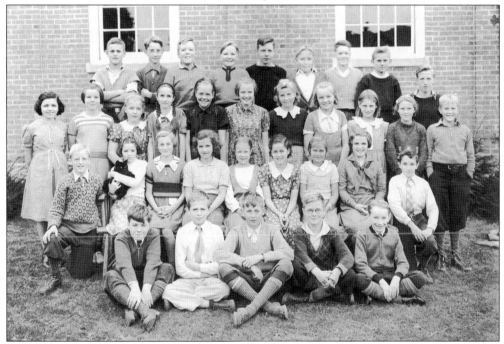

This Loughlin Junior High School class includes, from left to right, the following: (first row) unidentified, Warren Towle, unidentified, Carlton Murray, and Phillip Hills; (second row) Robert Ogilvie, Rowena Reed, Ruth Harold, unidentified, Barbara McAdams, unidentified, Sylvia Sutela, Georgiana Marshall, and Edwin Cahill; (third row) Jenny Arcangeli, Elaine Bevis, Hilma Kamila, Nancy Rice, Edith Friberg, Janet Cossaboom, Martha Kempi, Mildred Waltanen, Virginia Moore, Leah Walker, and unidentified; (fourth row) Carl Smith, Herbert Lawton, William Jamsa, Paul Kujanpaa, Robert Boucher, unidentified, Earl Reed, Frank Skorko, and unidentified. (WHS Collection; donated by Fraser Noble.)

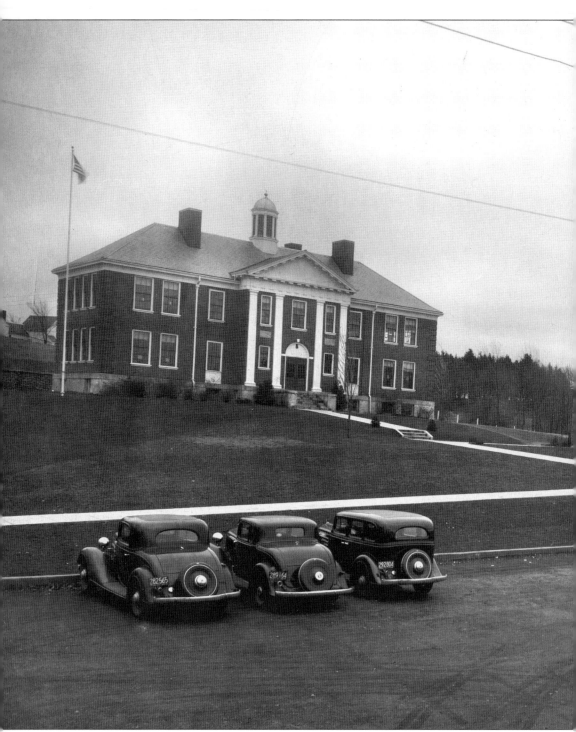

The growth of the town has been steady since the beginning of the 1900s, requiring new schools. Soon after the Upton School was built in 1912, additional space was needed as the district schoolhouses closed one by one. In 1935, the Loughlin School was constructed. This included

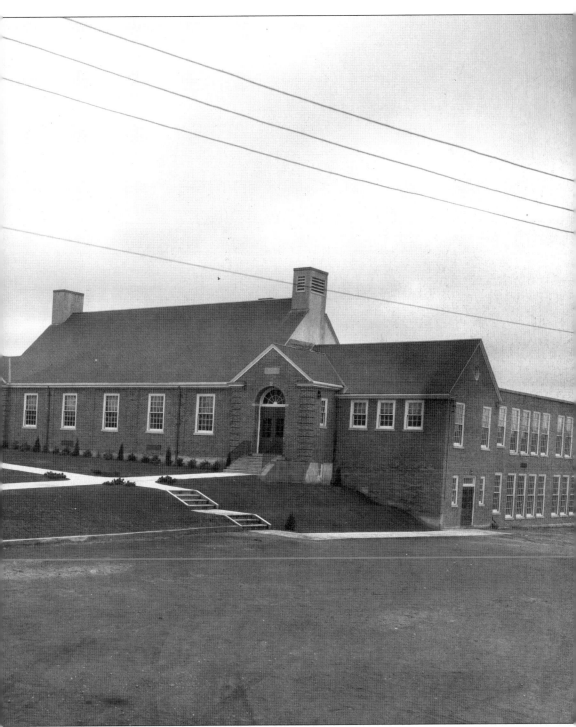

several classrooms, administrative offices, and the town's first gymnasium. By the look of the cars, this photograph was probably taken soon after the school opened. (WHS Collection.)

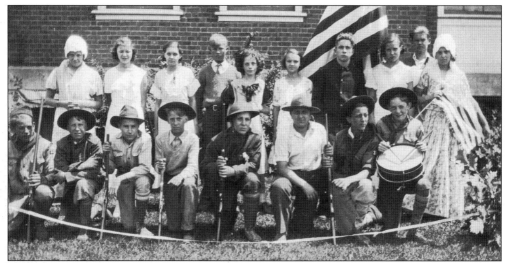

Costumed students in front of the Upton School *c.* 1930 celebrate Flag Day by presenting a program. They are, from left to right, as follows: (front row) John Ojala, Roy Mansur, Gordon Smith, Toivo Mattson, Herman Viewig, Dante Arcangeli, Vincent Tarmasewicz, and George Henstridge; (back row) Phyllis Young, Lempi Tuomi, Effice Mayranen, Martin Janhunen, Anita Husari, Marion Wather, Charles Smith, Taimi Arcangeli, Edward Sutela, and Catherine Smith. (Courtesy of Betsy Hannula.)

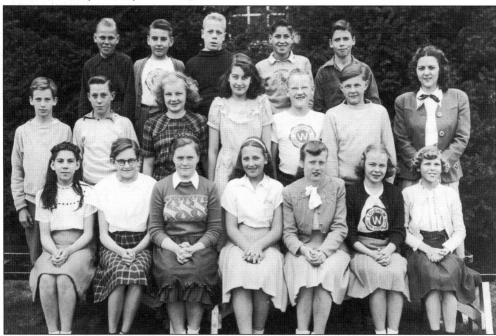

A Loughlin Junior High School class from *c.* 1949 includes, from left to right, the following: (front row) Theresa Rameau, Mary Lee Woodward, Pam Morse, Crystal Gardner, Joanne Towle, Arlene Luoma, and Judith Elola; (middle row) Lawrence Ball, Leo Rameau, Alicia Hopponen, Elizabeth Laughton, William Turner, James Powers, and teacher Mrs. Joseph Meloon; (back row) Robert Elola, Richard Carlson, Eddy Reynolds, ? Rameau, and George Norris. (WHS Collection.)

Upton School first-graders in 1937 are, from left to right, as follows: (front row) Virginia Andreasson, Aino Hintala, Audrey Page, Barbara Towle, Irene Hanninen, Janet Holmes, Irene Beauregard, Janet Stanbridge, unidentified, and Joan Henstridge; (middle row) Roy Barrett, Wesley Battles, Kenneth Stone, Richard Ahlin, Richard Moore, Donald Lawrence, Robert Smith, and Maurice Bennett; (back row) Arthur Robbins, Walter Chatnigny, Donald Caswell, Ralph Clark, Richard Hurme, Eino Jarvenpaa, and Voitto Johnson. (Courtesy of Richard Ahlin.)

A seventh-grade class from Loughlin Junior High School in 1941 includes, from left to right, the following: (front row) Joanne Barthel, Betty Kelty, Jackie Battles, Jean Rowe, Louise Holland, Vera Rose, Irene Harrington, Susan Jones, and Frances Page; (middle row) Lorne Stevenson, Irja Janhunen, Marilyn Remse, Dorothy Boucher, Sylvia Morse, Beverly Lanson, Grace Merriam, Lili Tuomi, and Violet Nappila; (back row) Veikko Honkala, Kenneth Sunne, Waino Niemi, Roland Boucher, Robert Boucher, Eino Sutela, Stuart Butterfield, and Bob Murray. (WHS Collection; donated by Fraser Noble.)

Five
FRUITS OF OUR LABOR

In the early days of Westminster, most families farmed because stores that offered the basic necessities of life were few and far between. It was commonplace for families to keep a cow for milk and butter, pigs and sheep for meat, chickens for eggs, and a horse or two for working in the fields and for transportation. The fields were planted with vegetables and grains, such as wheat or oats. Flax was grown for weaving linen cloth, and sheep's wool was saved for making wool thread.

Farming was not the only occupation in those early days. Sawyers cut trees into boards to build houses, and millers made grain into meal. Small stores supplied some items such as cloth, which could be traded for farm products. When entrepreneurs began to harness the power of the streams, factories were built, thus providing jobs for many people. Chair making and papermaking became important industries in Westminster.

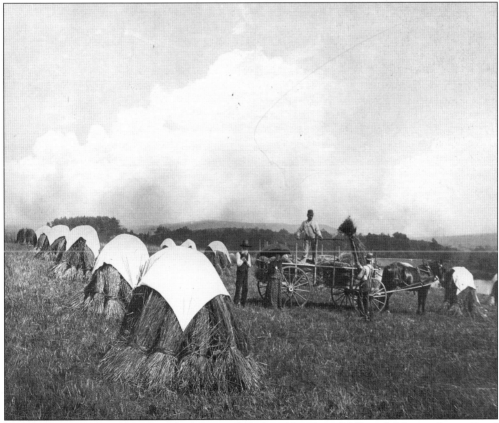

This late-1800s haying scene took place on the side of Academy Hill, with Meetinghouse Pond in the background. Pictured doing the haying are Israel Dickenson (born in 1831); his wife, Hattie; her father, Jonathan Hamilton; and a hired hand. (WHS Collection; donated by Sarah F. Gallop.)

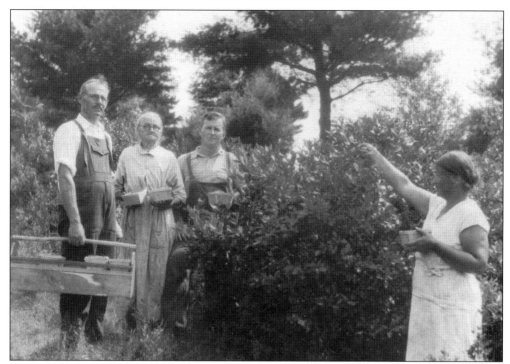

Blueberries were an important cash crop in Westminster for Finnish farmers. Shown picking blueberries on the family farm on East Road are Otto Leino; his mother, Helena Perkola; his son, Leo P. Leino; and his wife, Emily Leino. (Courtesy of Ceil Leino Burgess.)

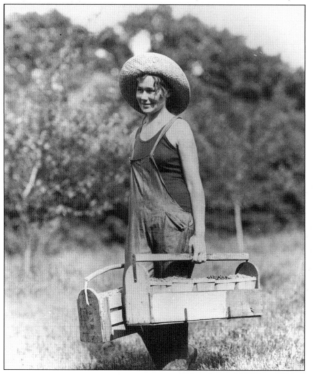

Martha Leino picks blueberries on the family farm. The berry carriers were handmade and carried 8 or 10 quarts of berries. Children often picked berries to raise money to buy a new set of clothes for school. Westminster farmers picked blueberries all summer and brought them to Haymarket Square in Boston early in the morning several times a week. (Courtesy of Ceil Leino Burgess.)

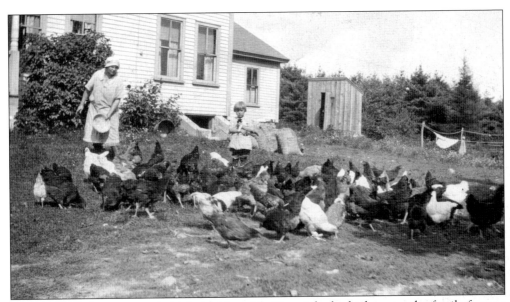

Many Finnish farmers raised chickens. Here, Ida Tuomi feeds chickens on the family farm at 144 Davis Road with her daughter Lempi. Axel Tuomi purchased the farm in 1920 and, by the 1950s, had 20,000 chickens in addition to cows and pigs. Note the outhouse in the background. (Courtesy of Betsy Hannula.)

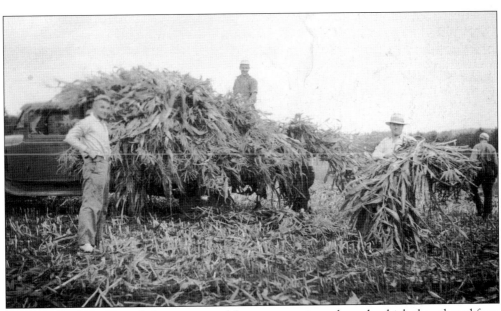

In the early 1900s, Finnish farmers created farm cooperatives, through which they shared farm equipment. The equipment was so expensive that one farmer could not purchase it individually. In the fall, a corn-threshing machine harvested corn at every farm. All the farmers in the cooperative helped each other fill their silos with corn for the livestock to eat during the winter. (Courtesy of Betsy Hannula.)

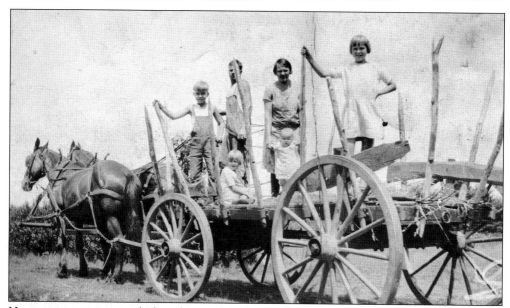

Horses were a necessity before the gasoline engine was invented. On the farm, horses were useful because they could go where cars and trucks could not. Axel and Ida Tuomi and their three daughters—Irene, Lili, and Lempi—ride on the farm wagon *c.* 1928. A young hired hand stands on the left. (Courtesy of Betsy Hannula.)

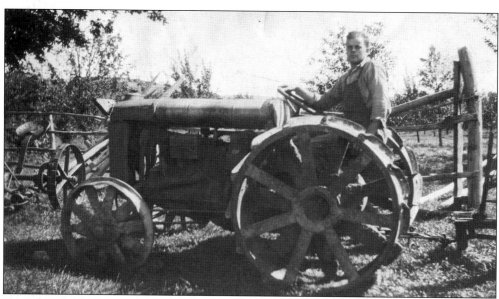

Axel Tuomi rides his tractor on the farm on Davis Road. In the early 1900s, it was common for immigrants from Finland to buy run-down farms and make them flourish again. By the 1930s, several Finnish farmers had settled here—the Winters, Lucanders, Johnsons, and VanHazingas—and Westminster became known for dairy and chicken farms. (Courtesy of Betsy Hannula.)

Cows graze on the front lawn of the Whitney Homestead at the corner of Davis and Lanes Road *c*. 1910. (Courtesy of George Lane.)

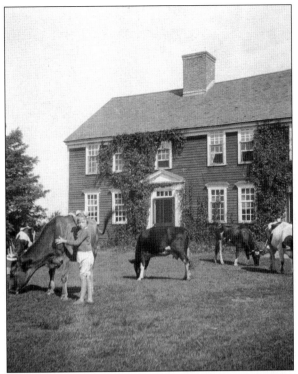

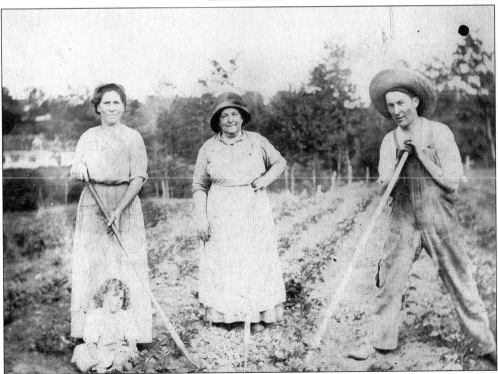

Vitaline Melanson Goguen, Lucy Poirer Goguen, Tom Goguen, and Lillian Goguen work in the gardens at their home on 137 Narrows Road. (Courtesy of Lillian Williams.)

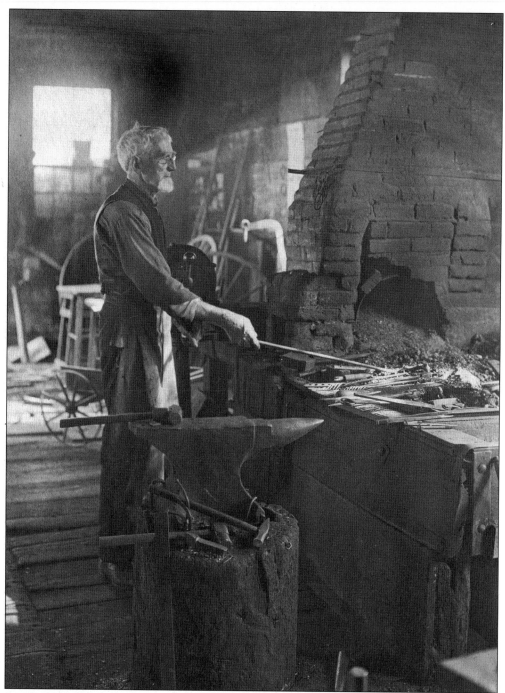

Stephen Lamb, born in 1834, is shown here plying his trade as a blacksmith. He was following in the footsteps of his father, Greenlief, who started a blacksmith shop on Main Street, near the spot later occupied by the Bruce Store and Johnny's Market. Greenlief built a home and blacksmith shop at 8 Bacon Street, where this photograph of his son was taken. Besides being a skilled blacksmith, Stephen was a respected citizen of the town, having filled the office of assessor and several other positions. (WHS Collection.)

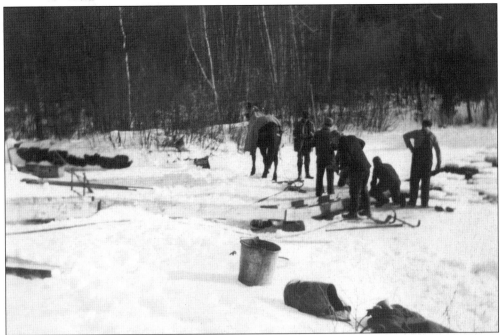

Until the mid-1900s, electricity was not available to rural areas. Families depended on iceboxes to keep food cold. Farmers earned money during the winter by going into the ice-cutting business. They cut layers of ice from local ponds into large blocks with saws. Horses dragged the blocks of ice to the wagons. Later, conveyor belts made the job easier. (WHS Collection; donated by Eva Coombs Lord.)

The icehouse on Meetinghouse Pond is shown in January 1946. The ice-cutting business required icehouses in which to store the blocks of ice through the spring, summer, and fall until the next winter. The blocks of ice were packed with layers of sawdust for insulation so they would not melt. Farmers delivered the ice to homes for families to use in their iceboxes. (WHS Collection.)

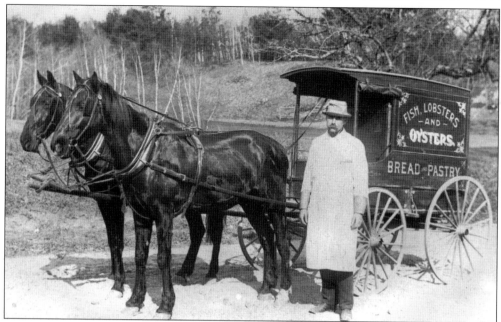

George Smith sold fish, lobsters, oysters, bread, and pastries from this delivery wagon. It was commonplace to see produce dealers like this delivering their goods to homes. This photograph was taken *c.* 1900 near the railroad underpass on Route 2A. (WHS Collection; donated by Roger Smith.)

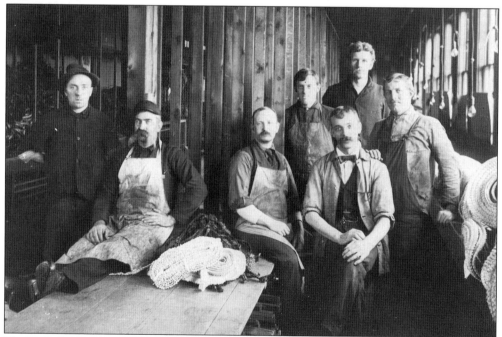

These workers made straw hats in a factory in the early 19th century. Work was divided by gender. The women did much of the sewing, and men performed the pressing and finishing work. Braiding rye straw for the hat industry was also done at home for many years. (WHS Collection; donated by Robert Mason.)

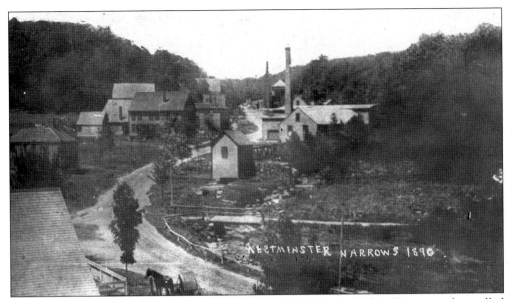

One of the most active industrial areas in Westminster was the Narrows, also called Wachusettville, at the intersection of Narrows and East Roads. From there, Wyman's Pond fed a river that ran down along Narrows Road and powered many factories. The 1831 map of Westminster shows a gristmill, sawmill, clothing mill, cotton mill, and fulling mill. After Wyman built a dam on the pond, a paper mill was also built. (WHS Collection.)

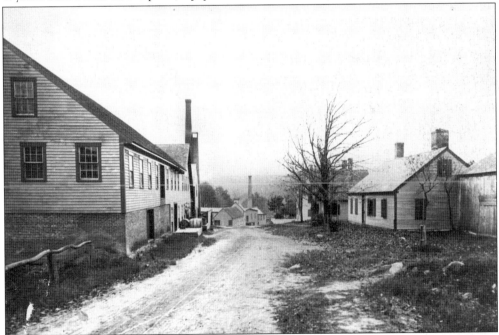

This view of Wachusettville was taken near the dam on Wyman's Pond, looking down Narrows Road. Franklin Wyman first manufactured chairs and then ran a paper mill here from 1845 until 1890. In addition, he built tenement housing for his workers. The City of Fitchburg purchased Wyman's property to increase its public water supply. Manufacturing here came to an end early in the 1900s. (WHS Collection; donated by Sally Oja.)

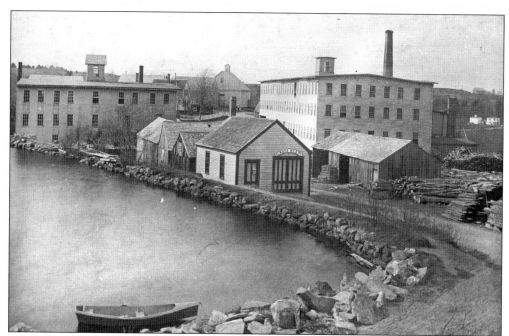

South Westminster was a busy chair-making center. The Merriam Chair Factory was built in 1843 along Spruce Road and Meetinghouse Pond by Artemas Merriam. There was such danger of fire that a small fire station was built to house the fire engine, called "Always Ready." Nevertheless, in 1869, the factory and all its contents burned to the ground. It was rebuilt and later employed 75 to 80 people. (WHS Collection.)

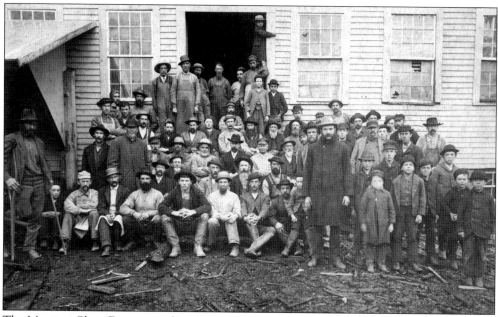

The Merriam Chair Factory employed more than 70 men, many of whom lived in the area and walked to work. (WHS Collection.)

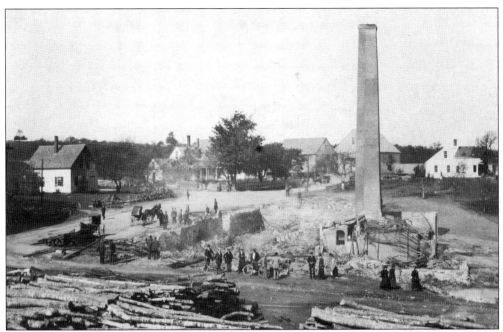

The Merriam Chair Factory in South Westminster burned to the ground in 1897. Merriam's house, in the background, was very large and had several outbuildings. The houses on the left and right are still standing. (WHS Collection; donated by Warren Sinclair.)

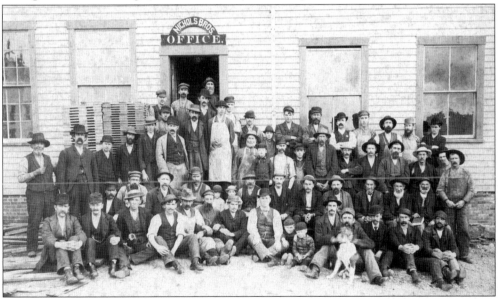

The Nichols Brothers Company, another chair-manufacturing business, began in 1857 on the northwest corner of Eaton and Main Streets. After a disastrous fire, the company decided not to rebuild in Westminster because the newly built railroad did not pass through the center of town. Under the name of Nichols and Stone, the company relocated to Gardner near the railroad. Shown in the front row are, from left to right, Frank Eaton, Fred Eaton, James Kelty, John Kelty, unidentified, Taylor, unidentified, Marcus Nichols, Carl Nichols, Arthur Nichols, Len Jackson, Fred Bolton, and Frank Sawyer. The others are unidentified. (WHS Collection.)

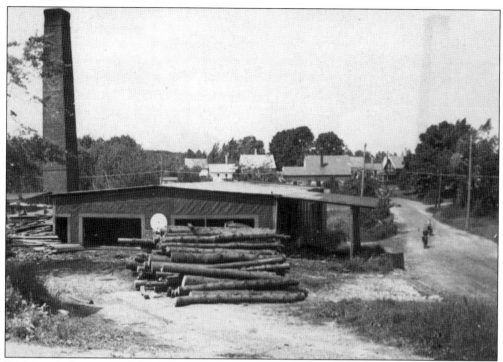

Fred Goodridge operated this sawmill and box-making shop at the foot of Bacon Street. Today, only the chimney remains as a reminder of this once prosperous business. (WHS Collection; donated by Martha French Savage.)

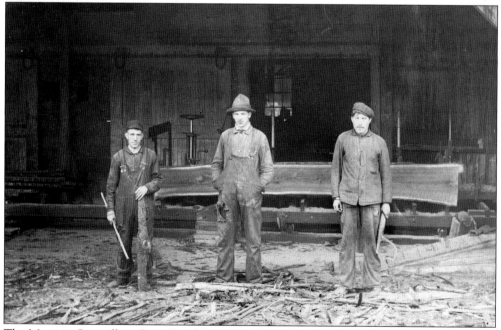

The Merriam Sawmill on State Road East was a busy place. On the left is Arno Hurd holding a measure with two other men, the last holding a log roller. The Merriam lumber and grain businesses here closed in 1943. (WHS Collection; donated by Anne Merriam.)

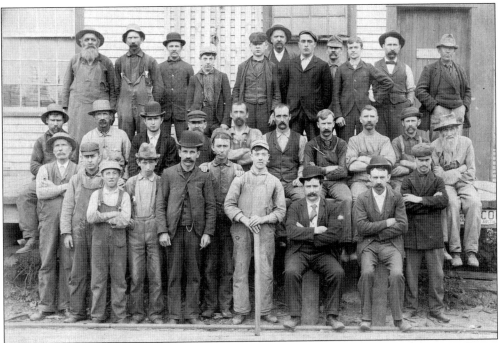

Caleb Merriam's son Eli Merriam had a flourishing business for many years on State Road East. This group of workers is standing in front of Eli H. Merriam's Grain Store and Lumber Mill. (WHS Collection; donated by Robert Havener.)

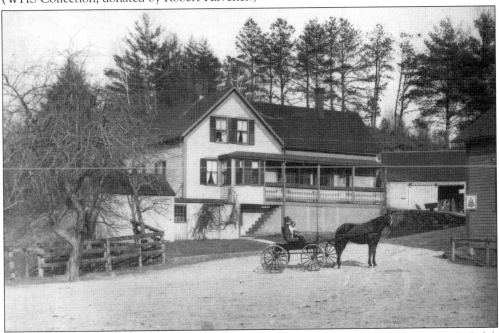

This property, at 148 State Road East, has been in the Caleb Merriam family since 1848. Caleb Merriam purchased the town meadows (now Round Meadow Pond), made them into a reservoir, and then developed the stream to provide power for several businesses. His family conducted a successful lumber production business and made chair seats. (WHS Collection.)

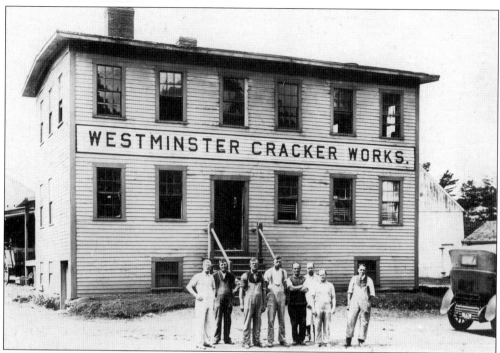

The Westminster Cracker Bakery, at 1 Academy Hill Road, was the longest-running business in town. It was started by Alfred Wyman in his home next door in 1845. Later owners were Charles Dawley, Frank Battles, and Herman Shepherd. Under the Dawley family, the business made cracker crumbs for Pillsbury in the 1970s and later closed. (WHS Collection; donated by Aili Wilen.)

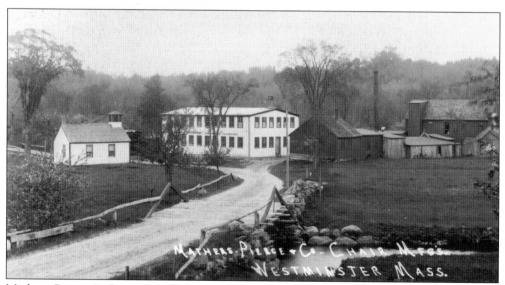

Mathers Pierce & Company, chair manufacturers, was located at North Common. Several Pierce family members were involved in lumber and chair making. This intersection was also known as Whitmanville. The schoolhouse is clearly visible here on the left. (WHS Collection; donated by Roger Smith.)

Six

SERVING OUR COUNTRY

From the time of the first settlements to the present, the citizens of Westminster have answered the call of their country to fight for freedom. In response to the alarm at Lexington on April 19, 1775, through the close of the Revolutionary War, about 276 Minutemen and regular enlisted soldiers contributed to the war effort.

When the Civil War began, many farm boys who had not traveled more than a few miles from their home found themselves hundreds of miles away fighting and living in terrible conditions. Nevertheless, patriotism and adventure fueled many to sign up. A total of 120 men were credited to Westminster; 16 of them reenlisted for extended service. Many more were native to the town but served on other town's quotas. More than 40 local soldiers perished in the war; half of them died of disease. Four families each sent four brothers off to fight, a significant sacrifice for a community of only 1,600 citizens.

Westminster's most famous son was Nelson Miles, whose incredible career began during the Civil War and led to him being placed at the head of the U.S. Army during the Spanish-American War. Six other men from town participated in that war. When World War I ended, 62 names were etched on a monument, including two who had died while in the service. Likewise, men and women joined up during World War II to serve the country in its time of need.

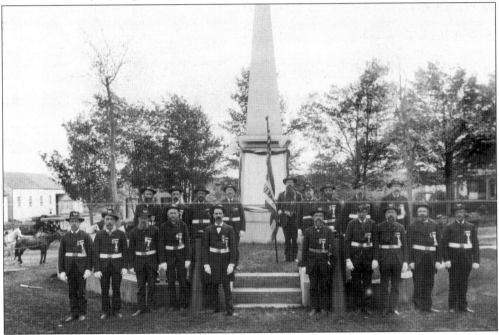

Civil War veterans of Westminster Joseph P. Rice Post 69, Grand Army of the Republic, are shown c. 1880. They are, from left to right, as follows: (front row) Hobart Raymond, Adin Baker, unidentified, Francis Eaton, Edward Kendall, James Miller, Lyman Drury, Henry Wetherbee, George Davis, and George Walcott; (back row) James Eaton, George Henderson, Joseph Marshall, George Rice, James Harrington, Edward Miller, Henry Partridge, Ottis Sawin, and Alonzo Bolton. (WHS Collection.)

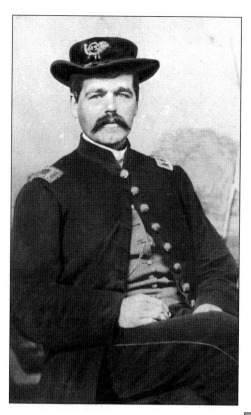

Cyrus Kingsbury Miller was born in Westminster and had once been a teacher. He was a lieutenant of Company B, 28th Illinois Infantry Regiment, in the Civil War. He was promoted for bravery at Fort Donelson but was stricken with fever at Vicksburg, where he died on July 8, 1863. The Sons of Veterans Camp 101 in town was named in his honor. (WHS Collection.)

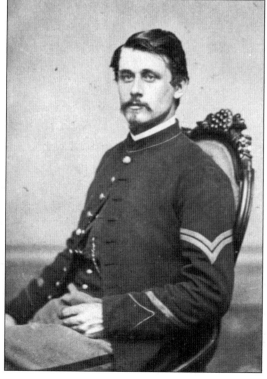

George Harlow Page participated in battles in North Carolina during the first three years of the Civil War. After several more battles, 76 percent of his regiment of the 25th Massachusetts Infantry was lost (75 killed, 122 wounded, and 32 taken prisoner) on June 3, 1864, at Cold Harbor, Virginia. George was wounded in the arm while charging the breastworks of the enemy there and died of his wound on June 26. (Courtesy of Fitchburg Historical Society.)

Thomas Augustus Petts joined Company A, 36th Massachusetts Infantry Regiment, in the Civil War. He was in the battle of Fredericksburg, the siege of Vicksburg, Jackson, Blue Springs, and Campbell's Station, Tennessee, where he was taken prisoner on November 16, 1863. He was sent to the dreaded prison at Andersonville, Georgia, where he died of typhoid fever on August 12, 1864. (WHS Collection.)

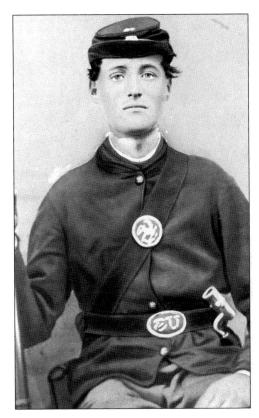

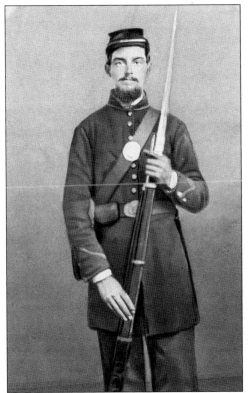

James Edwards Puffer Jr. served during the Civil War with Company A, 32nd Massachusetts Infantry Regiment. He was in all their major battles from Malvern Hill to Gettysburg, where he was shot in the chest and died instantly on July 2, 1863. His body was returned to town for burial. He was 22 years old. (WHS Collection.)

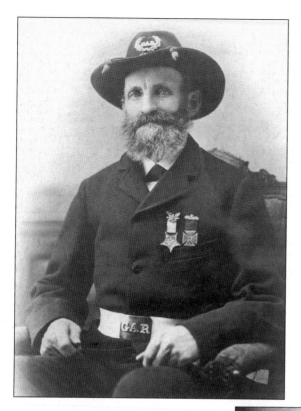

Amos Bradley Holden was a member of the Westminster Guards before the Civil War. He became a second lieutenant in the 32nd Massachusetts Infantry and a first lieutenant in the 1st Massachusetts Heavy Artillery, serving as an instructor. He recruited many men from Westminster during the war. He was very active in town and became the first commander of the Joseph P. Rice Post 69, Grand Army of the Republic. (WHS Collection.)

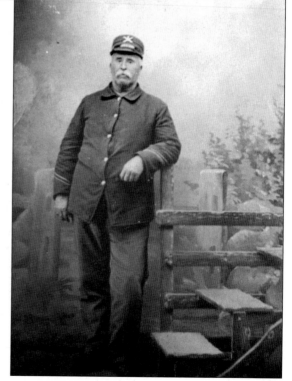

James Ferris Clark served as a drummer boy in the Civil War at age 15 in the 35th Massachusetts Infantry Regiment. Thirty years later, he served as drum major (shown here) of the 1st Massachusetts Heavy Artillery during the Spanish-American War in 1898. (Courtesy of Myrtle Parcher.)

Nelson Appleton Miles moved from Westminster to Boston at age 16. He helped to raise a company of men for the Civil War. Using his natural leadership skills, he rose through the ranks from first lieutenant to brevet major general at age 26. He fought in every major battle of the Army of the Potomac except Gettysburg. He was wounded four times and was awarded the Medal of Honor for bravery at Chancellorsville, Virginia. (WHS Collection.)

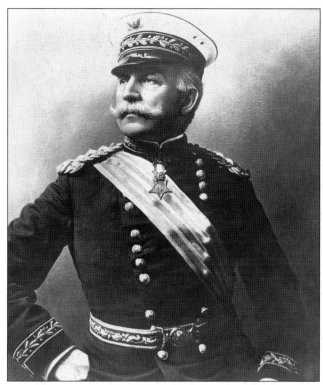

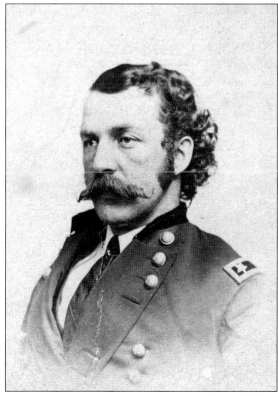

General Miles remained in the military after the Civil War and was stationed in the West. During the Indian Campaigns, he is credited with the capture of Chief Joseph and Geronimo. He rose in rank once again, becoming general-in-chief of the U.S. Army in 1895. He held this position through the Spanish-American War in 1898 and retired a full-ranked lieutenant general in 1903. He died in 1925 at the age of 85 in Washington, D.C. (WHS Collection.)

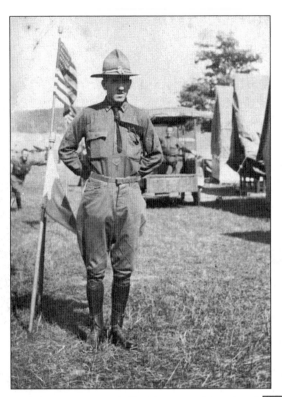

Edward Alphonse Lafortune was with the military police of the 6th Massachusetts National Guard. He served throughout France and was discharged on April 29, 1919. Three Lafortune brothers, Arthur, Edward, and Ernest, all from Westminster, were in World War I. This photograph was taken when Edward was at Fort Devens in 1917, before he was sent overseas. (Courtesy of Jacqueline Lafortune.)

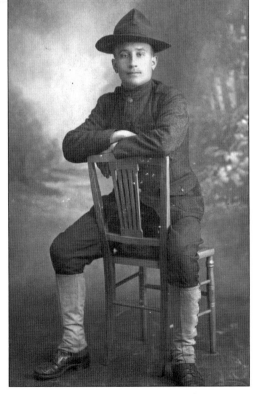

Ivar Tiiainen was born in Wiitasar, Finland, and lived in Fitchburg. He was a fireman when World War I started and enlisted in Company F, 6th Engineers, and in the Censor & Press Company ASC, until his discharge on July 1, 1919, as a sergeant. He served overseas from December 5, 1917, until June 29, 1919. He lived on Bacon Street in Westminster from 1927 until his death at age 87. (WHS Collection; donated by Wilho Mayranen.)

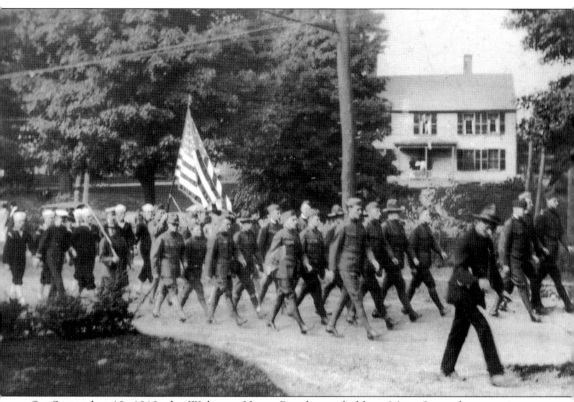

On September 19, 1919, the Welcome Home Parade was held on Main Street for returning World War I soldiers. Following the parade was a band concert, a banquet, speeches by General Miles and former Sen. Marcus Coolidge, and finally a tribute to Rollin M. Cannon and William S. Miller, who had died during the conflict. (WHS Collection; donated by Roger Smith.)

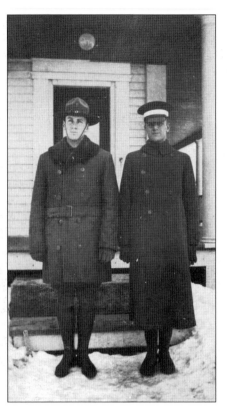

Brothers Chester E. Sargent (left) and Carl A. Sargent pose on Christmas Day 1917. Chester served as a second lieutenant of field artillery in World War I and was overseas from January through September 1918. He stayed in the service as an instructor and was assigned to a tank destroyer group as a colonel in World War II. Carl was a second lieutenant in World War I, training in military aerodynamics schools. Carl also served in World War II. (Courtesy of George M. Lane.)

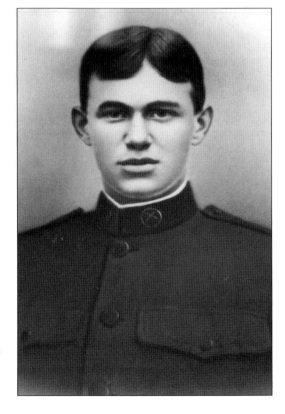

William S. Miller served in two different companies during World War I. He first served with Battery B, 18th Battalion, Field Artillery Recruit Depot. Upon his arrival in France with the American Expeditionary Force, he was transferred to Company I, Regiment 53, Pioneer Infantry Regiment. He arrived in Europe on August 6, 1918, but died of pneumonia on September 8, 1918. The Westminster American Legion post was named in his honor. (Courtesy of Mark Landry.)

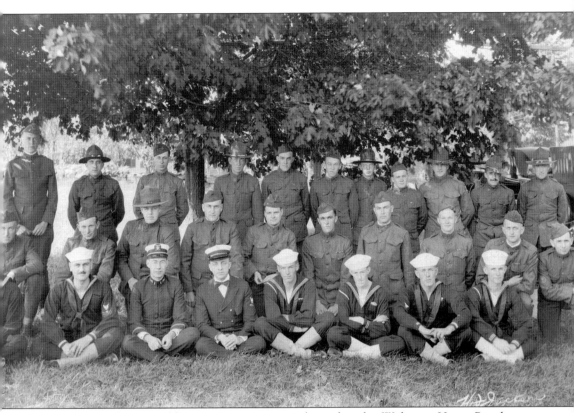

This photograph of World War I veterans was taken after the Welcome Home Parade on September 19, 1919. Shown, from left to right, are the following: (front row) Henry L. Curtis, Charles S. Merriam, John A. Sargent, Arthur K. Rice, Charles D. Towle, Leslie E. Harris, John J. Miller, and Daniel W. Havener; (middle row) Roger W. Battles, Hervey W. Bell, Paul E. Derby, Guy L. Miller, Thomas H. Holmes, Roland C. Houghton, Harry N. Howard, Arno E. Hurd, Harold A. Towle, and Kenneth R. Durling; (back row) John R. Carlson, Arthur E. Withington, Richard F. Hanks, Arthur G. Eaton, Raymond I. Stockwell, Emory J. Raymond, George F. Cannon, Roy W. Stockwell, Winfred E. Merriam, Harry E. Withington, and Benjamin H. Page. (WHS Collection.)

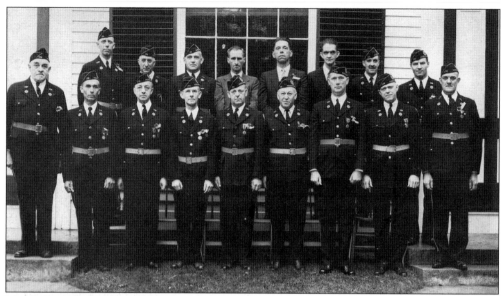

Members of the American Legion Post 174 pose in this May 29, 1938 photograph. They are, from left to right, as follows: (front row) Louis B. Gilson, Ernest T. Barrett, Arthur K. Rice, Daniel W. Havener, James F. Murray, Emory J. Raymond, Charles Bullock, Matthew E. Handlin, and Raymond I. Stockwell; (back row) A. Charles Hicks, Arthur E. Withington, William B. MacAloney Sr., James H. Totman, Jack Jamsa, Paul N. Woodward, Harry E. Withington, and Charles D. Towle. (WHS Collection.)

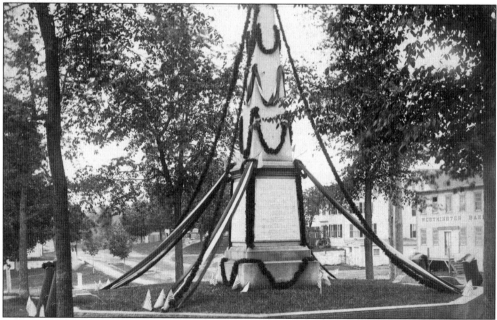

Even before the Civil War was over, the town had planned to erect a monument dedicated to its fallen heroes. After three years, it was finished and located on Main Street in front of the Congregational church. It is made of Fitchburg granite and was dedicated on July 4, 1868, with an elaborate celebration. The names of 34 soldiers who perished during the war are etched on its sides. (WHS Collection.)

Joseph Hager was very active in the community. He was on a committee of three in 1861 to care for the town's sick, wounded, and dead in the Civil War. His nephew Marcus Hagar died while serving in the army. Joseph was also on the Civil War Monument committee in 1865. In 1909, he erected this cast-zinc monument listing the names of Revolutionary soldiers from Westminster. It is located in Woodside Cemetery. (WHS Collection; donated by Fraser and Marion Noble.)

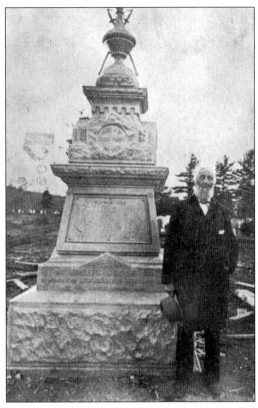

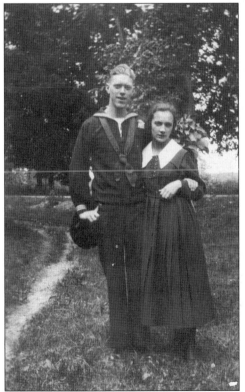

Matthew "Dewey" E. Handlin Jr. was a radioman second class in the U.S. Navy during World War I, serving aboard a German ship that had been transformed into an American troop ship. This photograph of him and Ruth Burns was taken c. 1917. They married in 1920. Matthew was also commander of Westminster's American Legion Post 174 from 1935 to 1936. (WHS Collection; donated by Beverly Lothrop.)

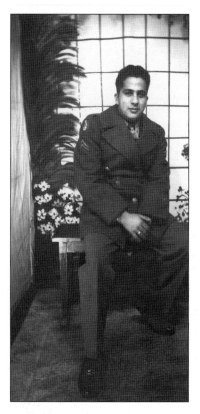

Joseph F. Aveni served aboard a B-24 bomber crew as a radio operator/gunner in World War II. He flew 44 missions in the China-Burma-India theater with the famed Flying Tigers. He earned the Distinguished Flying Cross, among his many decorations. After the war, he served as principal of the Westminster Elementary School for 28 years. (Courtesy of Betty Aveni.)

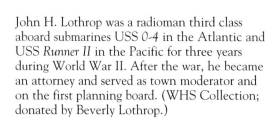

John H. Lothrop was a radioman third class aboard submarines USS 0-4 in the Atlantic and USS *Runner II* in the Pacific for three years during World War II. After the war, he became an attorney and served as town moderator and on the first planning board. (WHS Collection; donated by Beverly Lothrop.)

Frank Fenno Jr. was a very talented and successful submarine commander in World War II. He earned many medals, including the Distinguished Service Cross for transporting more than 20 tons of gold and silver in 1942 from Manila Banks that probably would have fallen into Japanese hands. On his way to Pearl Harbor, he sank three enemy vessels in high seas. His remarkable service extended for more than 30 years. (WHS Collection.)

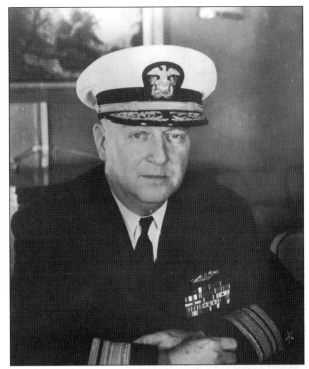

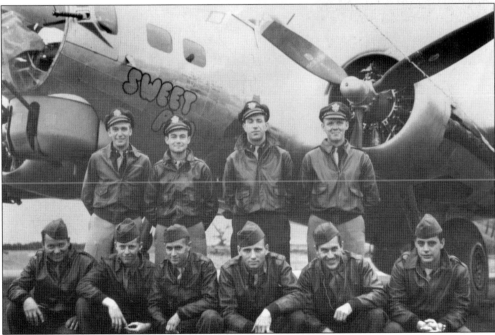

Douglas E. Hicks, kneeling second from the left, was an engineer/top turret gunner on a B-17 in the 8th Army Air Force during World War II. His crew's B-17, *Bouncing Betty II*, was severely damaged by flak, damaging two engines, on September 28, 1944, near their target of Magdeburg, Germany. Douglas bailed out of the plane and was killed. He was buried in Westminster in 1949. (WHS Collection; donated by Ernest Tuescher.)

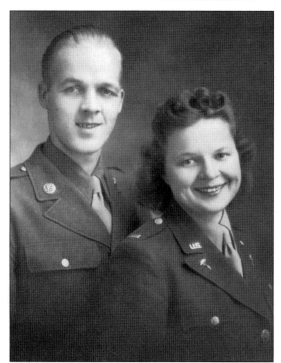

Lempi Tuomi graduated from the Henry Heywood School of Nursing in 1939 and left her work at Heywood Hospital to enter the Army Nurse Corps as a first lieutenant in April 1942. She served in the Pacific Theater in New Guinea until December 1944. Wilho Aalto was a sergeant in the U.S. Army Air Corps stationed in Mitchell Field, New York, from February 1942 to December 1945, which made up most of his service. They married in January 1945 and settled in their hometown of Westminster. Lempi retired in 1976 after 27 years as an elementary school nurse in town; Wilho retired in 1979 after 27 years as the custodian of the school. (Courtesy of Betsy Hannula.)

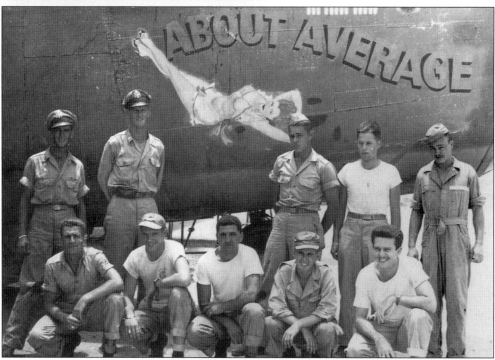

Dante P. Arcangeli (front row, center) was a staff sergeant in World War II, serving aboard a B-24 crew as an armor gunner in the 13th Army Air Force. Aside from his duties of making repairs to the aluminum skin of his planes, he flew 40 bombing missions over and around the Philippines. (Courtesy of Eunice Arcangeli.)

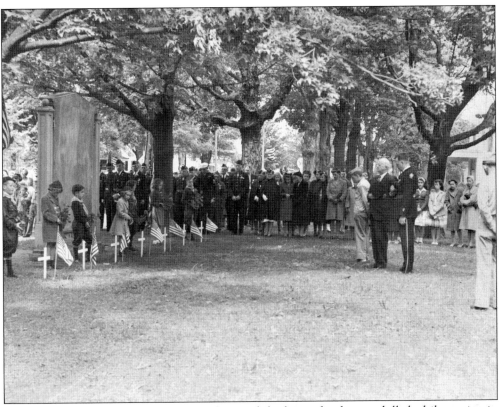

Memorial Day ceremonies held in 1945 honored the lives of eight men killed while serving in the armed forces during World War II. It took place in front of the library on Main Street. The honor roll plaque can be seen behind the children on the left. (WHS Collection.)

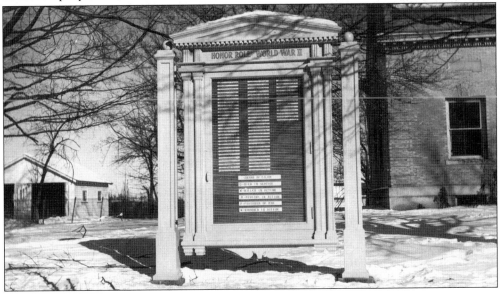

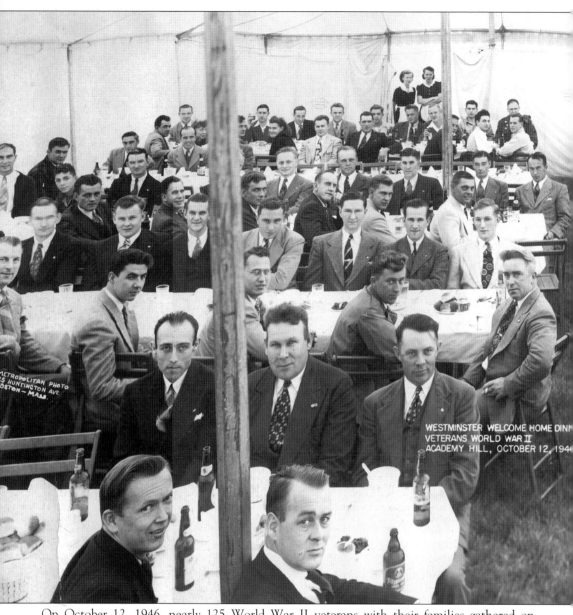

On October 12, 1946, nearly 125 World War II veterans with their families gathered on Academy Hill for an official welcome home dinner. Later that evening was a local band concert, followed by dances and a huge bonfire. Shown at the tables on the left are, from left to right, the following: (first row) Harold Muhonen and Eli Kahkola; (second row) Martin Dewey, Walter Wintturi, and Harold Strom; (third row) Eino Jaaskelainen, Kirwin "Bud" Bilson Jr., Ray "Bucky" Mansur, Ray Hicks, and Willard Gates; (fourth row) Howard Morse, Urpo Nikki, Alen Waronen, Alex Krysil, Paul Kujanpaa, Robert Havener, and Robert Oglvie; (fifth row) Robert Moore, Harold Murdock, Paul Newcomb, Fraser Noble, Gordon Leavenworth, and Alan Leavenworth; (sixth row) Howard Smith, unidentified, Vincent Lombard, William Parnanen, George Engman, Herman Viewig, George Rivers, and Donald Grahn; (seventh row) Everett Hines; (eighth row) Ernest Rameau and Alvin Gallant; (ninth row) Charles Merriam, Charlotte Merriam, unidentified, Anne Merrriam, Nicholas Van Der

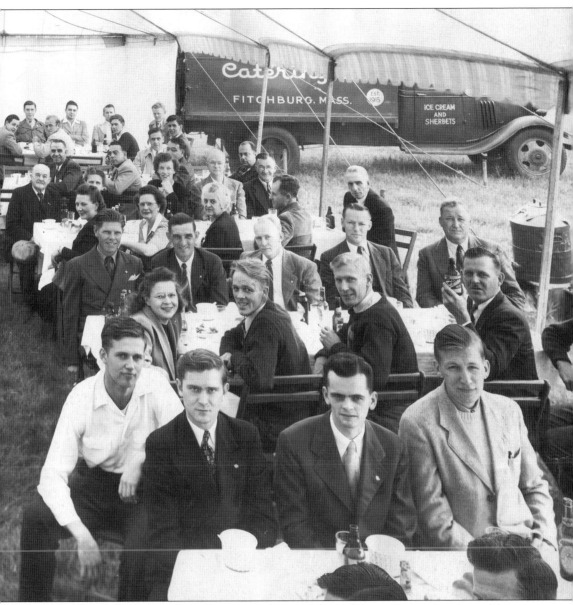

Mark, Edward C. Francis, Tom Luoma, unidentified, and Winston Dunn; (tenth row) Harry Walker, Henry Le Mieur, Benjamin Le Mieur, Leo Walker, Albert Rossner, and William Johnson; (eleventh row) Eimar Kurrikka, William MacAloney, and Albert Nelson. Shown at the tables on right are, from left to right, the following: (first row) Toivo Maki, Paul Boutel, and Harry Sutonen; (second row) Harold Towle; (third row) Lempi Aalto, Wilho Aalto, Eddie Muhonen, and Herman Sakkinen; (fourth row) Howard Winter, Arthur Holm, George Miukkinen, Elmer Luoma, and Oscar Ukkola; (fifth row) Anna Lucander, Gladys Towle, Marionn Kendall, Porter Dawley, and Roscoe Foster; (sixth row) William Stockwell, Doris Fenno, Helen Van Der Mark, Kirwin Bilson, and William Johnson; (seventh row) unidentified, Dr. Perkins, Dana Bevis, Walter Chatigney, and George Thomas; (eighth row) Frank Wiggins Jr., Ralph Young, Leo Grenier, and Robert Buckman; (ninth row) Lawrence Hicks, Armand Robillard, Robert Luoma, and Harold Young. (WHS Collection.)

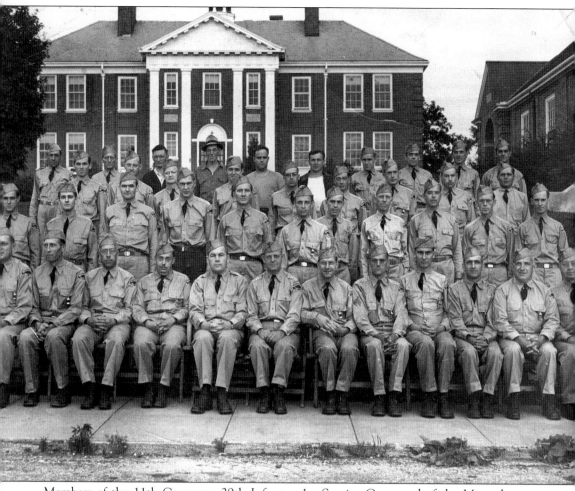

Members of the 11th Company, 29th Infantry, 1st Service Command of the Massachusetts State Guard were based in Gardner. There are many Westminster natives shown here in front of the Upton School. From left to right are the following: (first row) ? Sakkinen, Charles Innis, Vance Butterfield, Walter Chatigny, Guy Ralph, Albert Grenier, unidentified, George Bragdon, Howard Smith, Wilfred Lanoue, William MacAloney, and Arthur Rice; (second row) Chester Baker, Eddie Holmes, Ray Morse, Gordon Leavenworth, Eiro Legonen, Ron LeClair, Slim Gallant, Charles Hicks, unidentified, unidentified, and unidentified; (third row) unidentified, unidentified, ? Maki, unidentified, Francis Coombs, George Rivers, George Henstridge, Clyde Greeneregh, and unidentified; (fourth row) unidentified, Frank St. John, Guy Rhoades, Tom Chalmers, ? Newton, Nicholas Van Der Mark, Bill Roper, George Thomas, Paul Smith, and Preston Baker. (WHS Collection.)

Seven
REMEMBERING

Remembering special moments from the past—whether gathered from old family photographs or from tales of an elderly relative—has enriched the story of the history of Westminster.

Some of the moments represented in this chapter revolve around happy memories of summer. Families gathered at Wachusett Park to enjoy fishing and boating. Others, young and old alike, preferred spending time at the top of Wachusett Mountain.

Other memories spring from disasters. A snowstorm in the 1920s virtually shut down the town. In 1914, a massive train wreck at the Westminster Depot interrupted train service and badly damaged the station.

Still another memory comes from the state hospital, which was built within Westminster's boundaries but was called the East Gardner State Hospital. Here, the mentally disabled received treatment, and many local residents were employed.

Not to be forgotten are the celebrations of important anniversaries in the town's history. From the 150th anniversary parade in 1887 to the festivities commemorating the founding of the state in 1930, these events have been recalled with warm memories.

Finally, the town's good spirit and sense of humor are captured in a closing memory—an elephant on Main Street. It is an unusual sight but only adds to remembering Westminster's special moments from the past.

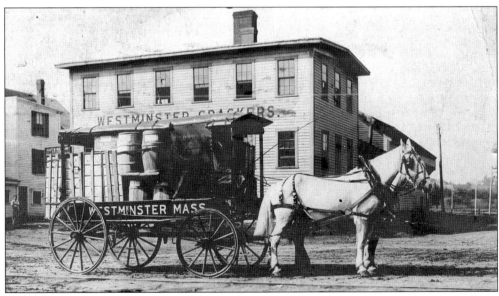

The Westminster Cracker Factory was a busy place. Horses and wagons carried products to the factory and delivered crackers to the customers. (WHS Collection.)

Wagons traveling up to Wachusett Mountain left deep ruts in the road. This view of the intersection of Mile Hill Road and Bolton Road illustrates the condition of the roads in the early days of Westminster. (WHS Collection.)

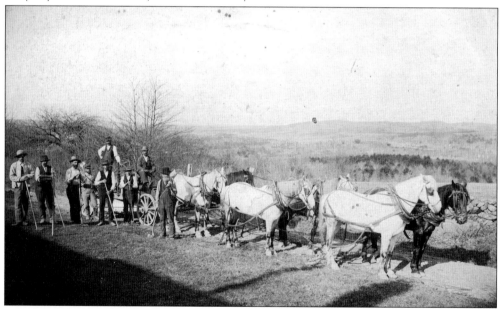

Working on the road near Wachusett Mountain was a long and treacherous job for these men of the Westminster Highway Department. Shown, from left to right, are the following: (front row) S. Parker, H. Bolton, ? Towle, E.R. Flagg, H. Hall, W. Burpee, and S. Bolton; (back row) William Sterling and W.H. Waterhouse. This carriage road brought vacationers to the Summit House every year. (WHS Collection; donated by Bertha W. Hutchinson.)

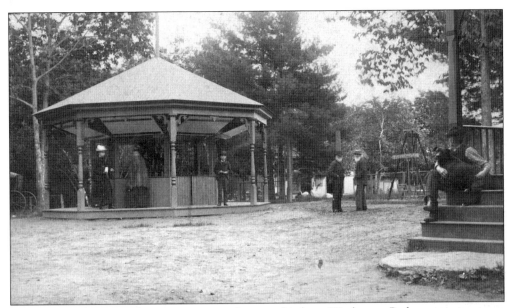

Simeon L. Bolton was the entrepreneur who gave birth to Wachusett Park, a summer resort located on the shores of Wachusett Lake on Mile Hill Road. He built a hotel, a large dancing pavilion, a bowling alley, fountains, a bandstand, and fishing and boating areas. The park soon attracted many visitors, who raved about the pout dinners. It was open from 1874 to 1920. (WHS Collection; donated by Bertha W. Hutchinson.)

The North View House was the home of Mrs. L.G. Brown and was later turned into a hotel for the park. Nearby was a large grove with summer cottages, picnic tables, and swings for children. Many farmhouses nearby were converted to summer residences or accommodated summer borders. The land around the park was slowly purchased by individuals, and soon the park closed. The land is now owned by the City of Fitchburg. (WHS Collection.)

These men are shown in front of the North View House at Wachusett Park c. 1920. It is apparent from the Yale University pennants that they are celebrating a reunion. People from all over the area came here by trolley. (WHS Collection.)

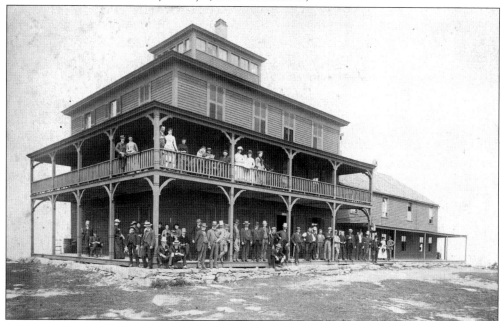

Wachusett Mountain—2,015 feet above sea level—overlooks all of Westminster. From 1870 to 1970, there were summit houses on top of the mountain that were clearly visible from many locations in town. This photograph shows the second house, located on the mountain from 1884 to 1899. The buildings on the summit were used for weather and fire observatories. (WHS Collection.)

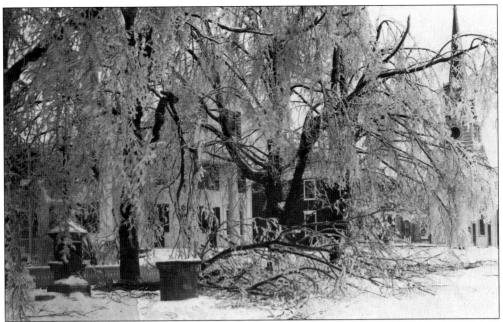

Pleasant summer outings gave way to ferocious winter storms, legendary in Westminster. An onslaught of snow and ice arrived in February 1921. Fallen branches littered Westminster's main thoroughfare. Behind the iced trees are the former Miller Home, the Brick Store, and the Baptist church. Note the watering trough for horses and a drinking fountain, which mysteriously disappeared some years later. (WHS Collection; donated by A.L. Stone.)

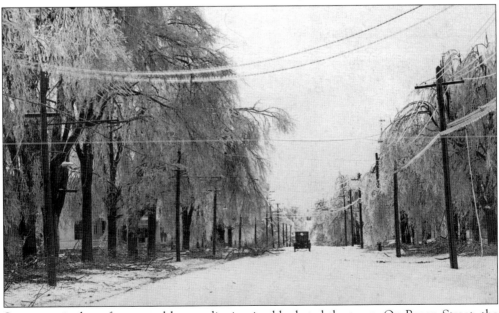

Seventeen inches of snow and heavy clinging ice blanketed the town. On Bacon Street, the damage to the trees was particularly severe. On the right is the town hall, next to the present Westminster Pharmacy. Tree branches leaned precariously, and power lines were knocked out. (WHS Collection.)

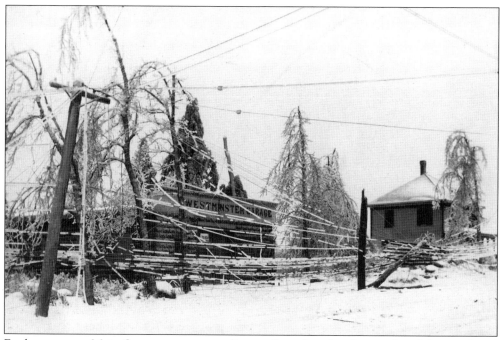

Farther west on Main Street, more power lines collapsed under the weight of the ice. Local newspapers reported severe traffic delays throughout the area. Shown behind the fallen lines are the Westminster Garage and the home of the Arcangeli family, prominent residents of the town for many years. (WHS Collection.)

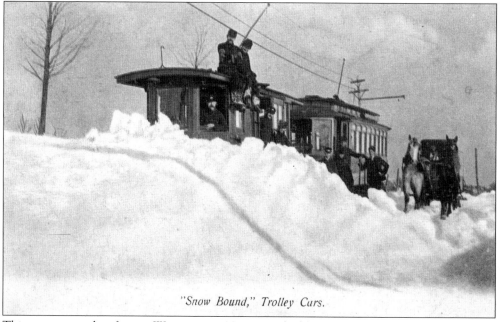

"Snow Bound," Trolley Cars.

This storm vented its fury on Westminster. Not since the blizzard of 1899 had the town suffered "such complete storm prostration," according to newspaper reports. Trolleys on the Gardner-to-Fitchburg line barely continued their runs. Note the two men with shovels and the snowbanks reaching the trolley windows. (WHS Collection.)

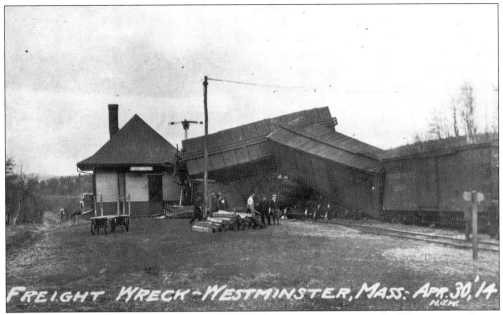

Another type of disaster struck on a pleasant April afternoon in 1914 at the Westminster Depot as a freight train swerved off the track, causing an immense 17-car pileup. The crash smashed windows and pushed the station some five to eight inches off its foundations. At left is the depot with its windows boarded up. (WHS Collection.)

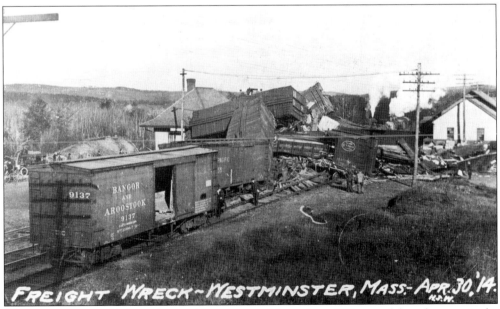

Clean-up crews rushed to the accident scene. More than 100 men labored unsparingly, gathering debris and burning refuse from the boxcars. Steam-driven derricks rushed to aid in the clean-up effort. After some 12 hours of intense work by the crews, service on the line was reopened. (WHS Collection.)

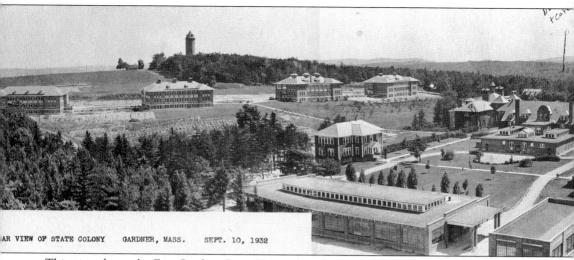

AR VIEW OF STATE COLONY GARDNER, MASS. SEPT. 10, 1932

This view shows the East Gardner State Hospital on September 10, 1932. The photograph was owned by Mr. and Mrs. William Bradford, who worked for the hospital for many years. (WHS

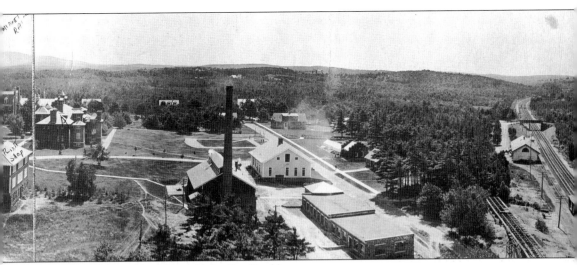

Collection; donated by Mr. and Mrs. Bradford.)

The Commonwealth of Massachusetts purchased land in Westminster to build a hospital for the mentally disabled. In more recent years, it was known as East Gardner State Hospital, until it closed in the 1970s. In the 1980s, it became a correctional institution. (WHS Collection.)

This is a group photograph of the employees of East Gardner State Hospital performing a minstrel show for the patients. It was taken in 1918. (WHS Collection.)

The East Gardner State Hospital was well known for its residential farm. This fair gave residents an opportunity to show off their produce and products. Pictured here is the candy booth. (WHS Collection.)

The fairs were well attended by area residents and produced income for the hospital. Wide areas of the landscaped lawns were set up with booths and entertainment. (WHS Collection.)

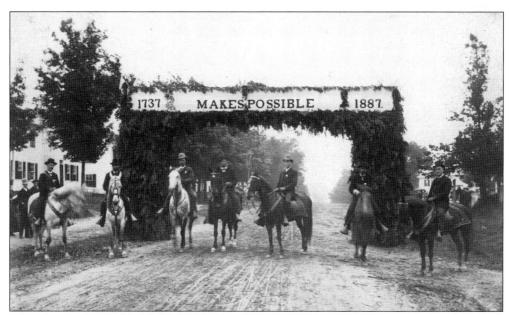

Dignitaries pose on horseback beneath a decorated arch in 1887 to celebrate the 150th anniversary of Westminster's first settler, Fairbanks Moor. (WHS Collection; donated by Frank W. Fenno.)

The parade in 1909 celebrating the town's incorporation was extensive. Two wagons for Edward W. Lynde's meat business are decorated for the parade. Shown from left to right are Arthur Willis, Fred Parcher, Stephen Darling, and Paul Woodcome. (WHS Collection.)

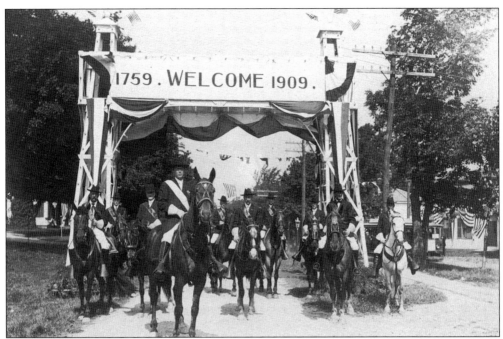

This parade in 1909 celebrated the 150th anniversary of the incorporation of the Town of Westminster. Parade dignitaries on horseback, under the welcome arch are, from left to right, W.H. Waterhouse, G.L. Dawley, W.W.H. Griffin, W.F. Fenno, Chief F.A. Laws, A.E. Gates, W.H. Laws, E.R. Miller, F.A. Curtis, and F.H. Battles. (WHS Collection.)

The welcome arch is lit by tiny electric light bulbs. This was most unusual because electricity was quite new, and streetlights were not common yet. (WHS Collection.)

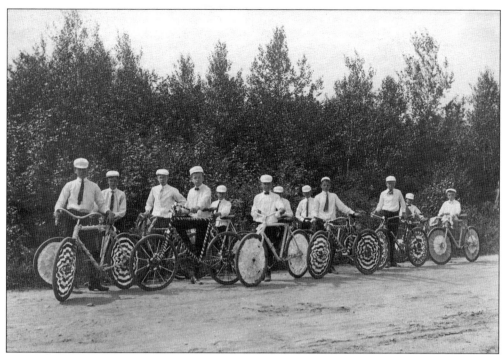

These young people, dressed for the celebration, have decorated their bicycles to ride in contingent for the 150th anniversary parade. (WHS Collection.)

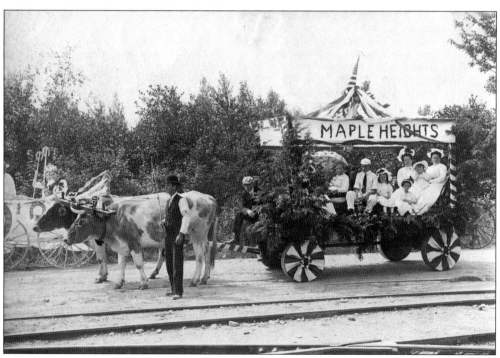

Albert Howard's float, "Maple Heights," was named after his home and was featured in the 150th anniversary celebration. He is pictured guiding the oxen. (WHS Collection.)

The Westminster Town Hall is shown decorated for the 1909 anniversary. Seen on the left is a gas streetlight. When the town hall was first built in 1839, it was a two-story structure. In the late 1900s, the building was raised and a new floor was constructed underneath. The first floor was used for suppers, the second floor for meetings and dances, and the third floor as a meeting hall for the Grange and the Grand Army of the Republic. (WHS Collection.)

This photograph pictures the Brick Store and the Joseph Whitman homes on Main Street decorated for the 150th anniversary celebration. Roy and Bessie Howard sit on the granite block to the left. The steeple of the Universalist church is visible in the background. (WHS Collection; donated by Brooks Goddard.)

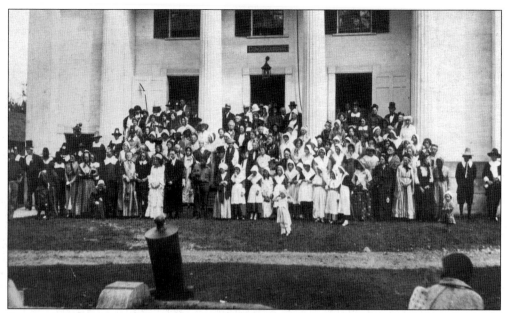

People from all over the state celebrated the tercentenary of Massachusetts in 1930. Westminster was no exception. Townspeople, dressed in period costumes, are shown gathered in front of the Congregational church to observe the celebration. (WHS Collection.)

Pictured in front of the Forbush Memorial Library is a sign announcing the events for the tercentenary celebration. Standing next to the sign is Nellie Miller with an unidentified friend, both dressed in appropriate costumes. (WHS Collection.)

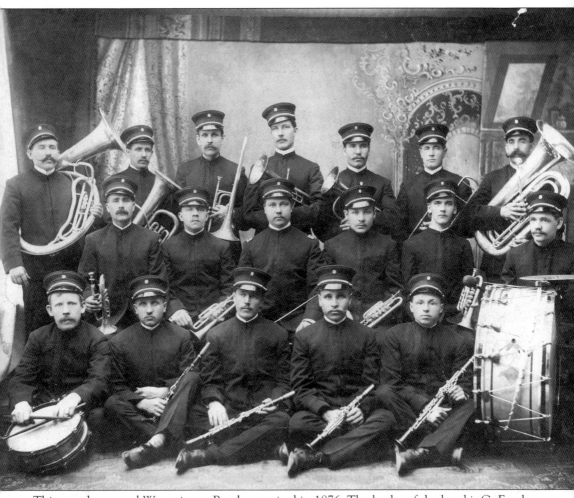

This was the second Westminster Band, organized in 1876. The leader of the band is G. Frank Urban, pictured in the center holding the baton. (WHS Collection.)

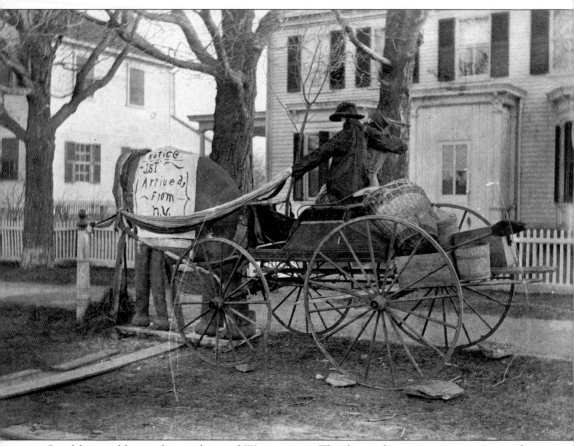

Good humor blesses the residents of Westminster. This horse-drawn carriage was erected in front of the home of Philip Loughlin at 98 Main Street. The elephant wears a blanket that reads, "Notice—Just arrived from N.Y." The joke was meant to welcome home the newlywed couple of Philip and Ann (Lewis) Loughlin after their wedding trip. (WHS Collection; donated by Warren Sinclair.)